SNO-ISLE REGIONAL LIBRARY

W9-DES-236

2006.

MYFAVORITEPLACE

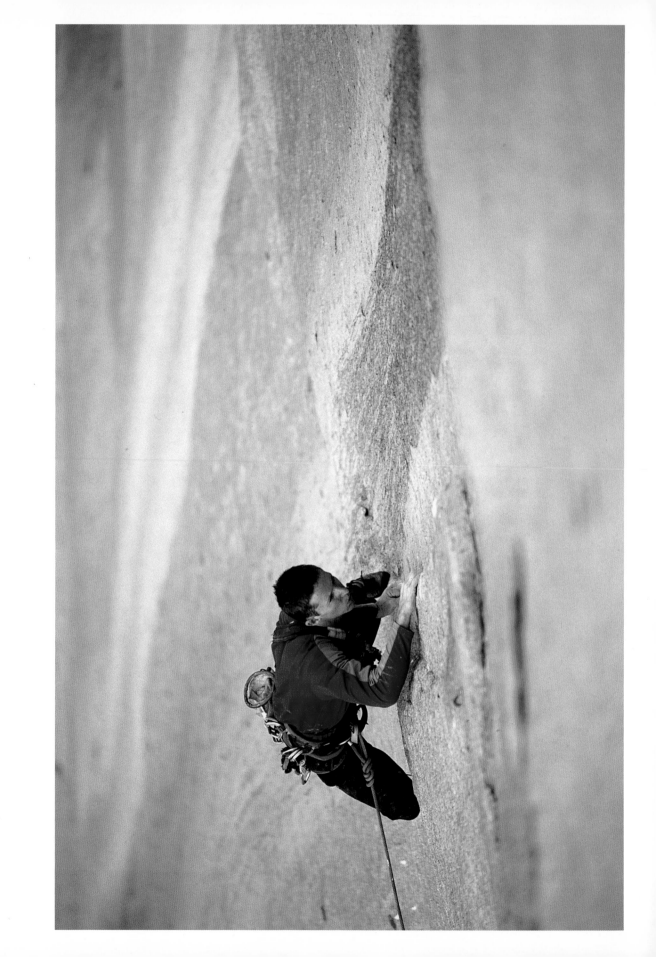

MYFAVORITEPLACE

great athletes in the great outdoors

BY **JASON PAUR**

PHOTOGRAPHS BY **COREY RICH**

CHRONICLE BOOKS
SAN FRANCISCO

Library of Congress Cataloging-in-Publication Data:

Paur, Jason.
My favorite place : great athletes in the great outdoors / by Jason Paur ; photographs by Corey Rich.
p. cm.
ISBN 0-8118-4323-8
1. Photography of sports. 2. Outdoor photography.
3. Athletes—Portraits. 4. Rich, Corey. I. Rich, Corey.
II. Title.
TR821.P38 2006
796'.092'2–DC22

2005010616

Manufactured in China.

Designed by **Jay Peter Salvas.**
This book was typeset in Minion Expert 9.5/14, Interstate 7.75/13, and Clarendon.

Distributed in Canada by Raincoast Books
9050 Shaughnessy Street
Vancouver, British Columbia V6P 6E5

10 9 8 7 6 5 4 3 2 1

Chronicle Books LLC
85 Second Street
San Francisco, California 94105

www.chroniclebooks.com

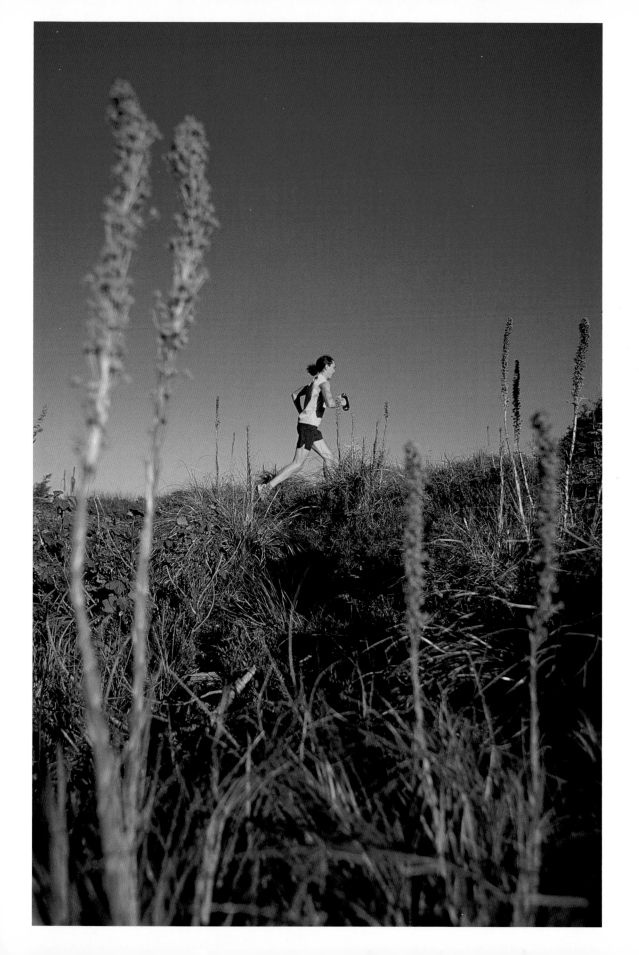

CONTENTS

INTRODUCTION Page 9

Lisa Andersen

01
PONCE DE LEON INLET, FL
SURFING
Page 11

Sara Ballantyne

02
MOAB, UT
MOUNTAIN BIKING
Page 21

Tom Bergh

03
PEAKS ISLAND, ME
SEA KAYAKING
Page 31

Tommy Caldwell AND Beth Rodden

04
YOSEMITE VALLEY, CA
ROCK CLIMBING
Page 43

Kari Castle

05
OWENS VALLEY, CA
PARAGLIDING
Page 53

Barrett Christy

06
MOUNT BAKER, WA
SNOWBOARDING
Page 65

Eric Jackson AND Family

07
ROCK ISLAND STATE PARK, TN
KAYAKING
Page 77

Scott Jurek

08

CASCADE MOUNTAINS, WA
TRAIL RUNNING
Page 87

Bill Koch

09

PUTNEY, VT
CROSS COUNTRY SKIING
Page 97

Jeff Lowe

10

OURAY, CO
ICE CLIMBING
Page 107

Shane McConkey

11

TWIN FALLS, ID
BASE JUMPING
Page 117

Kasha Rigby

12

WASATCH RANGE, UT
TELEMARK SKIING
Page 127

The Ross Family

13

NEW RINGGOLD, PA
THRU-HIKING
Page 137

Ed Viesturs

14

MOUNT RAINIER, WA
MOUNTAINEERING
Page 147

ACKNOWLEDGMENTS Page 160

"THIS IS MY FAVORITE PLACE!"

Those are the words, spoken emphatically. Those are the words we hear again and again, from our friends and when we say them ourselves—whether out loud or just in our head. We hear these words with arms extended, while stretching as we emerge from the car for the day's adventure. We hear them after we've caught the first wave, climbed the first pitch, or carved the first tracks. And we say them when the last mile is complete, after the final few paddles land us on shore, when we're already embellishing our stories for the week to come. All of us who love the outdoors connect to our own special spot, a place where we can close our eyes and still picture every rock, every tree, or every bluff along the shoreline. It's a place where we always feel at home. A place that always puts a smile on our face.

Outdoor adventurers—world champions, Olympians, elite guides, pioneers in their sport— are no different. Like the rest of us, they might visit playgrounds in Switzerland or Nepal or Fiji in search of exotic new terrain. They do it to earn their living and to push the limits of their sport. But when the expedition is over, when the competition is complete, they return to a place where they can practice the basics, polish their technique, and, most important, enjoy the simple pleasure of being outside and remembering what drew them there in the first place.

From the Vermont forest where Olympic medalist Bill Koch has been cross-country skiing for more than thirty years to the glacier-covered volcano in the Pacific Northwest where mountaineer Ed Viesturs learned the techniques that would take him to the summit of Mount Everest to the Tennessee River where kayaker Eric Jackson practices air loops for his next world championship, America is one long stretch of favorite places. And except for a few daunting locations (think bridges and tall cliffs), the outdoor hangouts profiled and photographed on these pages can be enjoyed by anybody who knows the fundamentals of his or her sport.

Something that struck Corey and me as we assembled this book is how many of these people have chosen to live as close as possible to their favorite place. Although the waves are wimpy, world-champion surfer Lisa Andersen settled on the Florida coast where she grew up, and where she still loves to surf. In contrast, professional skier Kasha Rigby wound up in Utah because of its natural assets: deep powder and diverse terrain. Only a handful of people featured here travel more than an hour or two to find consistent happiness. In many ways this defines a favorite place—it's a familiar spot where we're as comfortable as we were in our childhood backyard.

But few of us can walk out the backdoor to find reliable white water or miles of trails. Most of us have to bank time in order to enjoy our getaway. We work for a couple of months and sneak off for a long weekend. Or maybe work a few years to sneak away for a few months. But the important thing is that we continue to go, to throw the skis or climbing ropes into the car and set out in search of adventure. You may choose to return to an old favorite place, or to try something different and follow a friend to his or her favorite spot—or maybe even take a trip to one of the places described here. Steal the time if you have to, and make the pilgrimage. It's always worth the trip.

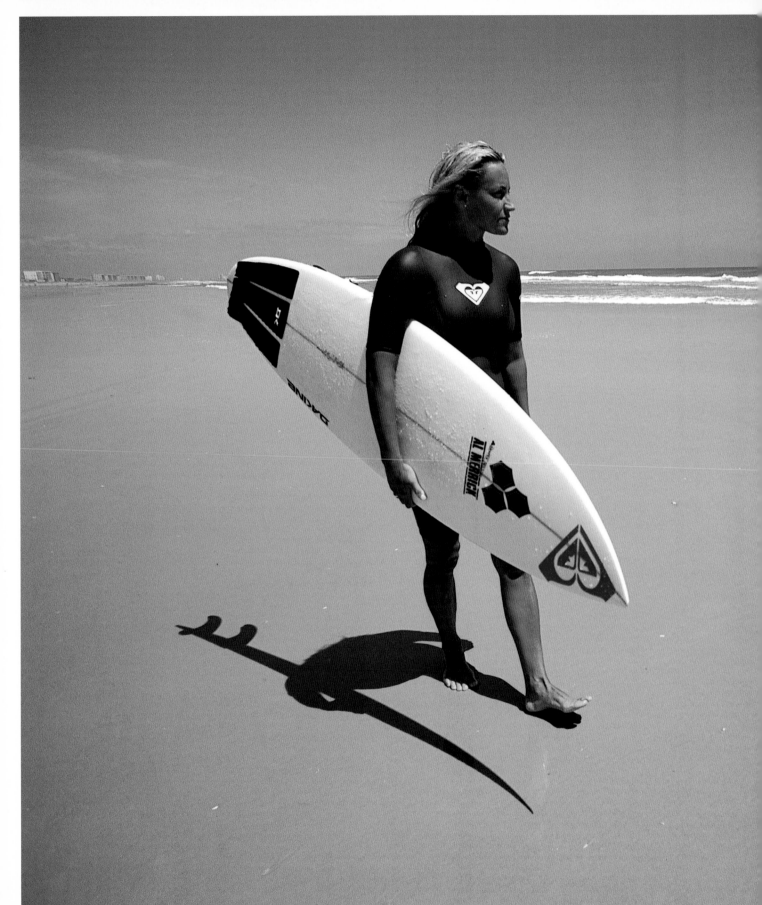

LISA ANDERSEN

01

MY FAVORITE
PLACE

12

Page

ATHLETE

Lisa Andersen

SITE

Ponce de Leon Inlet, FL

SPORT

Surfing

LATITUDE / LONGITUDE

29°06'N / 80°56'W

Sitting on the tailgate of her truck, four-time world-champion surfer Lisa Andersen is exhibiting the skills of a superstar. She's waxing her surfboard on autopilot, scanning the surf to see where the waves are breaking, and watching over her eleven-year-old daughter, Erica, who in turn is looking after Mason, Lisa's three-year-old son. The surf isn't that good here in Central Florida. But this is what makes Lisa a superstar—she makes the best of every situation put before her.

Confident that Erica has things under control on the beach, Lisa zips up her wetsuit—"I'm a wimp," she admits. "I only wear a swimsuit if the water is in the eighties"—and paddles out into a crowd of surfers, trying to find waves lost on the edge of the Atlantic.

Lisa uses her powerful shoulders to paddle and maneuver through the lineup of surfers along the short stretch of beach here at Ponce Inlet, where she first learned how to ride as a dreaming teen, not far from her current home. While rideable waves are elusive here, fans are not. "Oh my god! Is that Lisa Andersen?" one girl shrieks. As she tries to build up the courage to paddle over and say hello, a few guys are hovering close by to watch Lisa attack the next bit of swell. Largely credited with fueling the explosion of women's surfing during the 1990s, Lisa is still a little uncomfortable with the fame. "I just get embarrassed," she says of most of her encounters with fans.

Pelicans rise and fall, gracefully skimming the surface of the water. Lisa is scanning the ocean in every direction, looking for something she can ride. "The waves here really teach you to not take anything for granted," she optimistically explains. As the water rises up into a wave, she pops to her feet and demonstrates how she became surfing's first female icon. No matter what the ocean gives her, Lisa can rip.

Lisa grew up near this break but didn't start surfing until she was fourteen. That first year, she quit when winter arrived because she didn't have a wetsuit or her own board. "The next year, people loaned me boards and I really started surfing all the

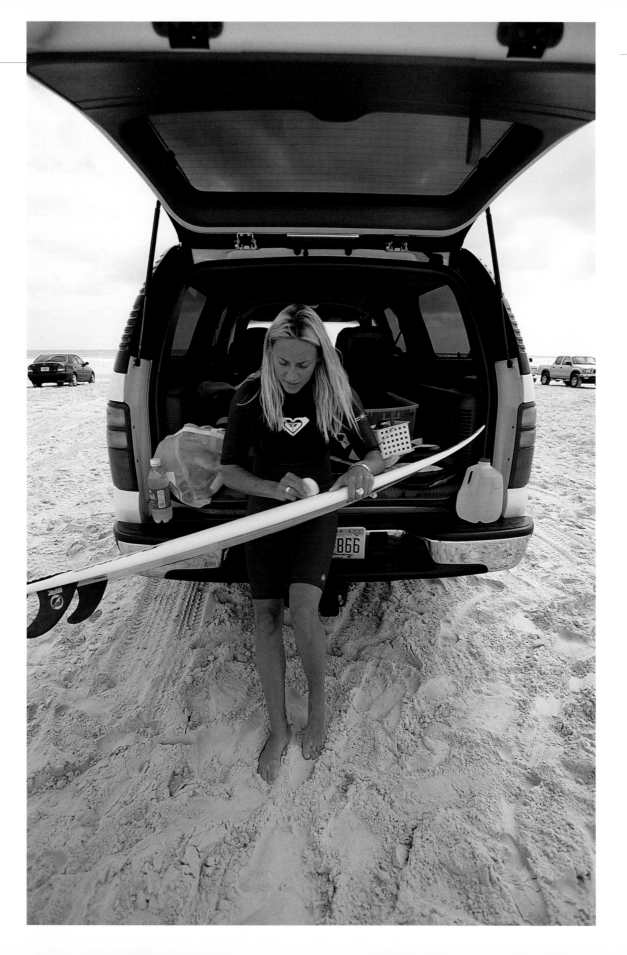

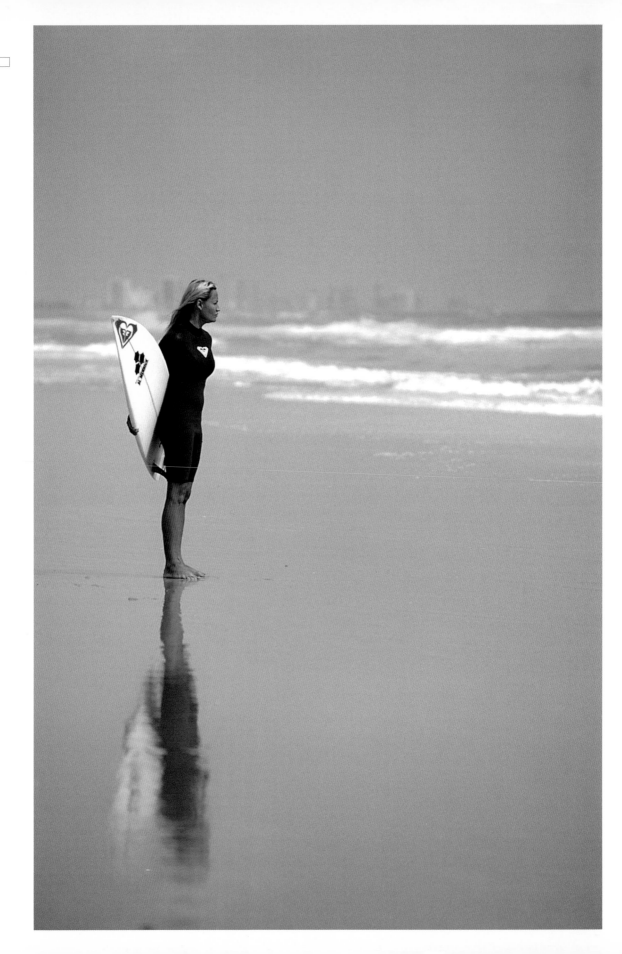

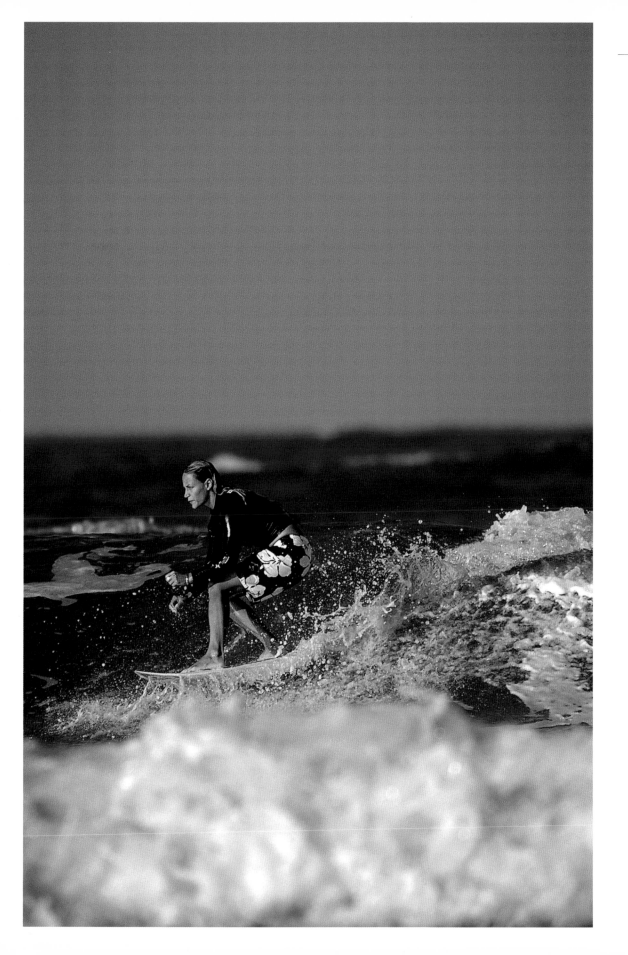

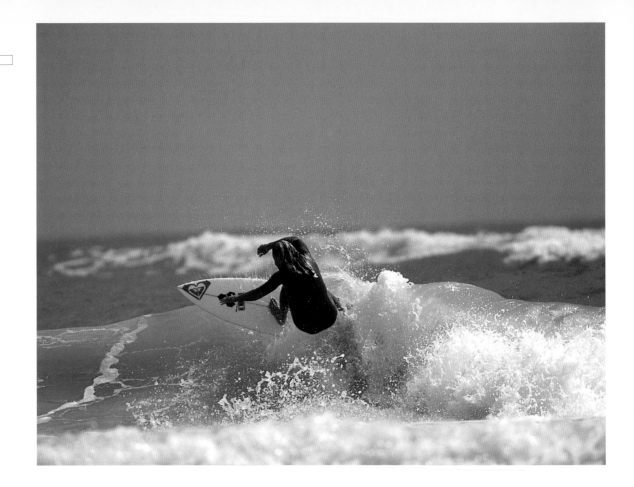

time, spending less time at school," she says. When her parents complained, Lisa rebelled. Surfing was her escape—"nobody could paddle out and get me"—and it eventually drove her all the way to California. At age sixteen, she left home, leaving behind a note saying she would become a world champion, though she now admits that she didn't even know there was such a thing.

In Southern California, she surfed every day and watched the pros, mostly men, every chance she got. Without many women to emulate, Lisa found herself paving a new path for female surfers. "I looked up to the men more, their style, their approach to the wave," she says of her role models. "I really only admired a couple of people, and I chose the best guys." Their style influenced hers, prompting what was in her mind the ultimate compliment: "You surf like a guy."

After winning many amateur events in California, Lisa struggled as a pro. "There was a lot of learning involved," she says of the early days. Life was difficult on her own: "Being on the tour and traveling was my high school." Lisa says she lacked focus, and it was keeping her from breaking through as a professional. Then she had Erica (after competing up through month six of her pregnancy), and, unexpectedly, at a time when many might flounder, everything fell into place. Being a full-time mom while

touring as a pro surfer gave Lisa perspective on what could be accomplished. "After Erica, I had to be focused, I had too much to do between diapers and everything else," she says. "It was a distraction from the distractions." She won the first of her four titles the next year.

Now retired from competition, Lisa is in her late thirties and enjoys being back in Florida, where she and the kids share a home with her mom. She continues to travel to exotic surf locales around the globe, from Indonesia to South Africa to Hawaii. And she knows there are better—much better—waves to be found elsewhere in the world. "My surf friends are all trying to get me to move out of here," she admits. "[But] there's just no place like home," she says with a grin. Walking back up the Ponce Inlet beach, Andersen checks in with her toddler. "Come on, Shorty," she says. Neoprene squeaking, she returns to the truck, balancing her board under one arm and her son under the other.

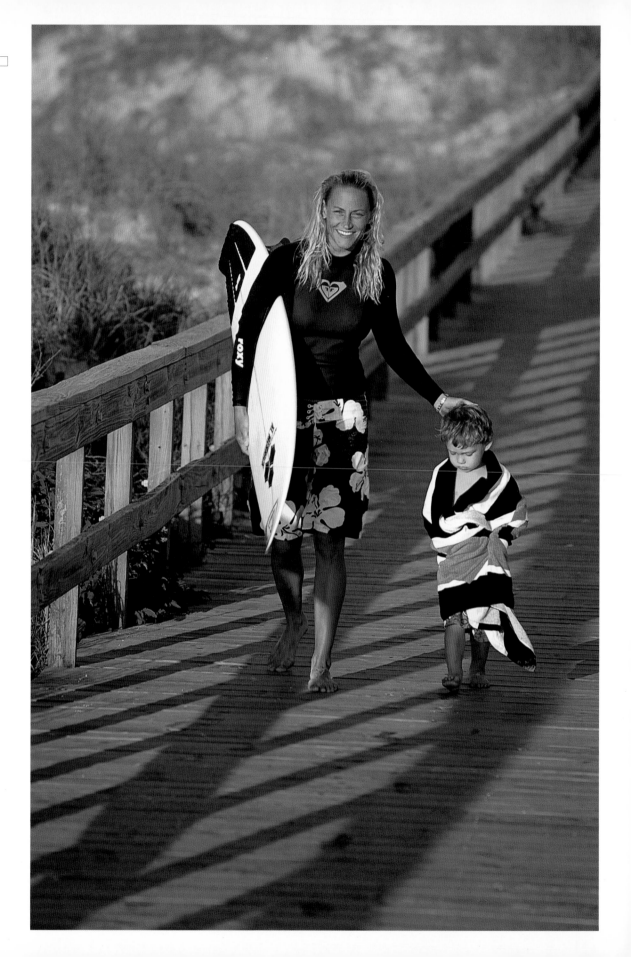

THE NIGHT BEFORE WE WERE SUPPOSED to meet Lisa Andersen at New Smyrna Beach in Florida, Jason and I were driving out from the airport in Orlando, just talking about whatever, and he casually dropped this bomb on me: "You know this beach has the highest concentration of sharks in America, right?" I almost yanked the e-brake right there and bailed out of the car. I hate sharks, and it turns out Volusia County is host to more shark attacks than any other county in America. Damn.

I had brought all this special equipment with me—an underwater camera housing, a wet suit, fins, a face mask—and I was totally pumped to be in Florida. It was snowing and cold at my home in Tahoe, and I was going to shoot surfing! I figured I'd be swimming out into this nice warm water and framing perfect barrels all day. Yeah, right. Now, I am a small guy, and in a full wetsuit I do kind of resemble, well, a seal. So I was thinking that there was no way in hell I was swimming out into a shark buffet with no surfboard, my legs hanging down like chicken drumsticks for anything that came by to munch on.

I didn't sleep very well the night before the shoot. I kept hearing the *Jaws* theme song playing over and over in my head, and I kept thinking about the mosquito bites I'd gotten and whether the sharks could actually smell the blood. When the alarm went off, I couldn't think of any excuse good enough to get out of shooting in the water. I got up, prepped all of my gear—fully intending to risk my life—and tried to remember if a will written on a napkin would be legally binding.

Driving out to the beach felt like walking the plank, but there must be some patron saint of panicky photographers, because when we showed up, I could see right away that the waves were just awful. They were so bad and inconsistent that even if I hadn't been terrified of getting mauled by a shark, shooting in the water still would have been impossible. So, with a total poker face, I said to Jason and Lisa, "Hey, I'm really disappointed about

this. These waves are just terrible. I guess with a long lens from the beach we could get something."

They bought it, but the truth is that even if there had been twelve-foot perfect barrels out there, I would have wanted to shoot from the beach anyway. Lisa had no trouble, though. There are moments that separate the exceptional athlete from your average surfer, and this was one of them. She just paddled out and ripped. It was incredible—there were all these strong young kids out there, with all the right gear, and most of them couldn't even get up on their boards. It must have been pretty humbling when this thirtysomething mom with two kids got out and shredded right past them. She was making these tiny, mushy little waves look fun, and I got everything from dry land without losing face.

In fact, until this book came out, nobody even knew how badly I was stressing out. Not even Lisa's agent, who called after the shoot to ask how it went. I kept up the pretense: "It was okay, but the waves weren't great. I could come back out . . ." I sort of left it hanging and hoped like hell he wouldn't call me on it. Wouldn't you know it—several months later, her agent phoned and told me excitedly, "Corey, you're not going to believe this. There's a huge swell rolling in tomorrow morning! It's going to be sick. And Lisa is in town. Can you make it?" For a second my heart dropped, but my luck held—I couldn't make it. When he called me, I was in the airport headed to a shoot in Peru, twenty thousand feet above any sharks. Thank you, patron saint of panicky photographers. Thank you.

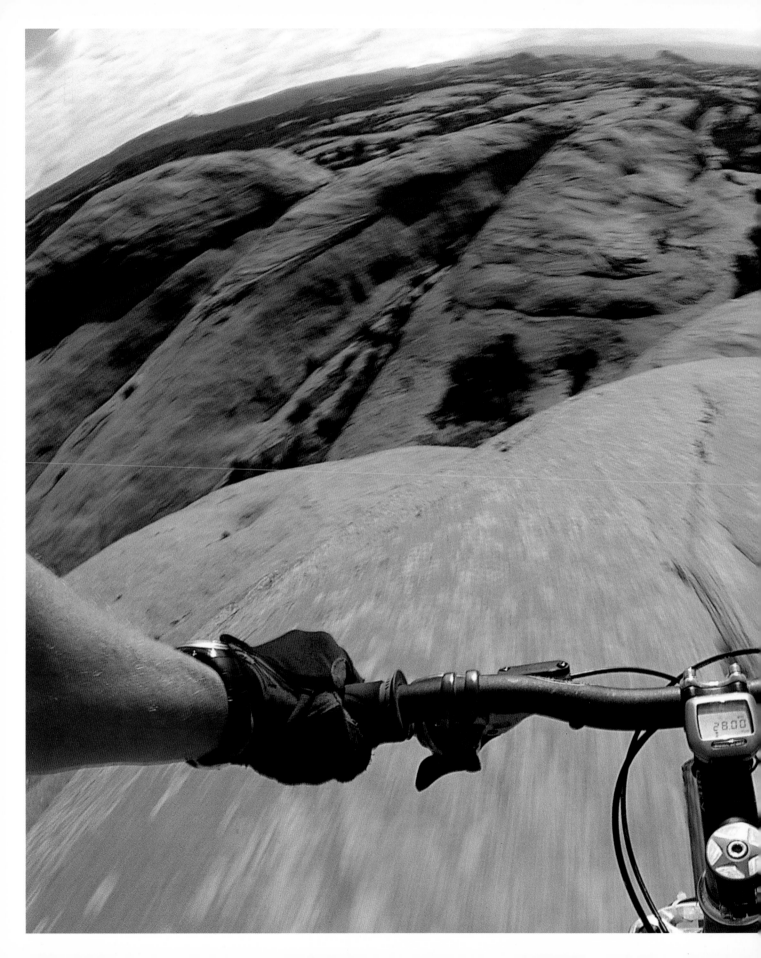

02

SARA BALLANTYNE

ATHLETE
■ Sara Ballantyne

SITE
■ Moab, UT

SPORT
■ Mountain biking

LATITUDE / LONGITUDE
■ 38°34'N / 109°33'W

Only in Moab do motels carry signs that read HOT TUB, HBO, BIKE SHOP. With one of America's best untamed playgrounds a short drive away, mountain bikers dominate this dusty old mining town high in the Utah desert. Moab hooked Sara Ballantyne twenty years ago, when she was working as a teacher and outdoor guide in the central Rockies and looking for a place to test out a new mountain bike. "You have to ride this thing called the Slickrock Trail," she recalls a local telling her.

Armed with sketchy directions, she drove out one night to find it in the nearby Sand Flats Recreation Area. She cruised slowly along a dirt road until her headlights illuminated an old wooden sign: Slickrock Trail. After sleeping on the roadside, she awoke to see in the distance the steep, bare rock the trail is named for. With no clue about the length of the ride (about ten very technical and strenuous miles) or the conditions (snakes, lizards, and sandstone), she hit the trail—"just swung my leg over the top tube and rode."

Sara was unprepared in just about every way: "I ran out of water, ran out of food; I was hiding under juniper trees to escape the sun and didn't see anybody the whole time." Sara returned to the truck, worn out by the hours of bone-jarring bumps (early mountain bikes lacked suspensions) and the numerous short, steep climbs on a heavy bike without the advantage of a granny gear. But that first day of exhaustion, sunburn, and skull-rattling riding turned her into a mountain biker, and a Moab junkie who would return again and again over the coming decades.

Now retired after more than a dozen years as a professional mountain-bike and adventure racer, the Colorado resident stands in the Slickrock trailhead parking lot, prepping for a ride. After a quick

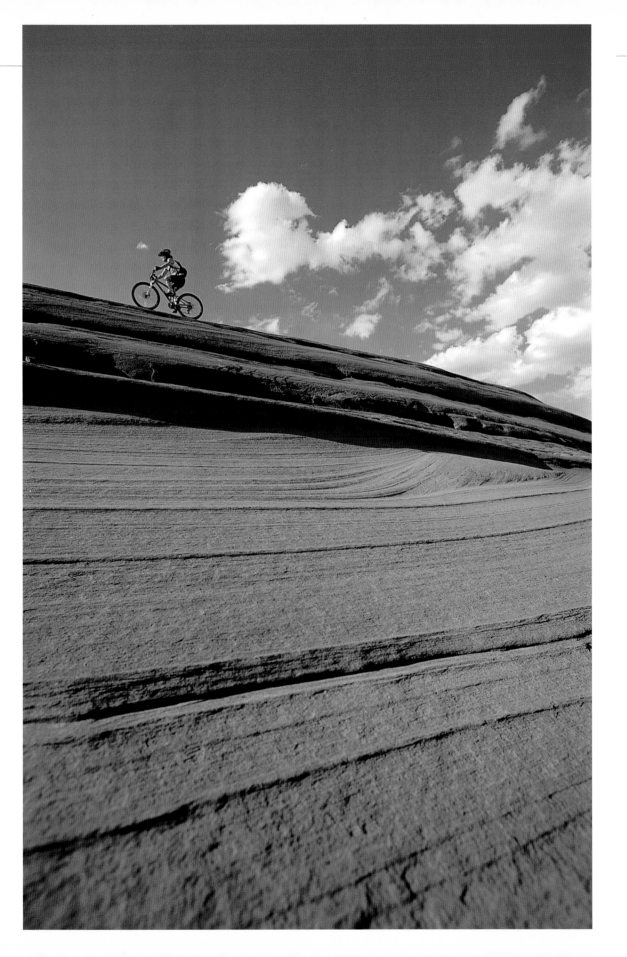

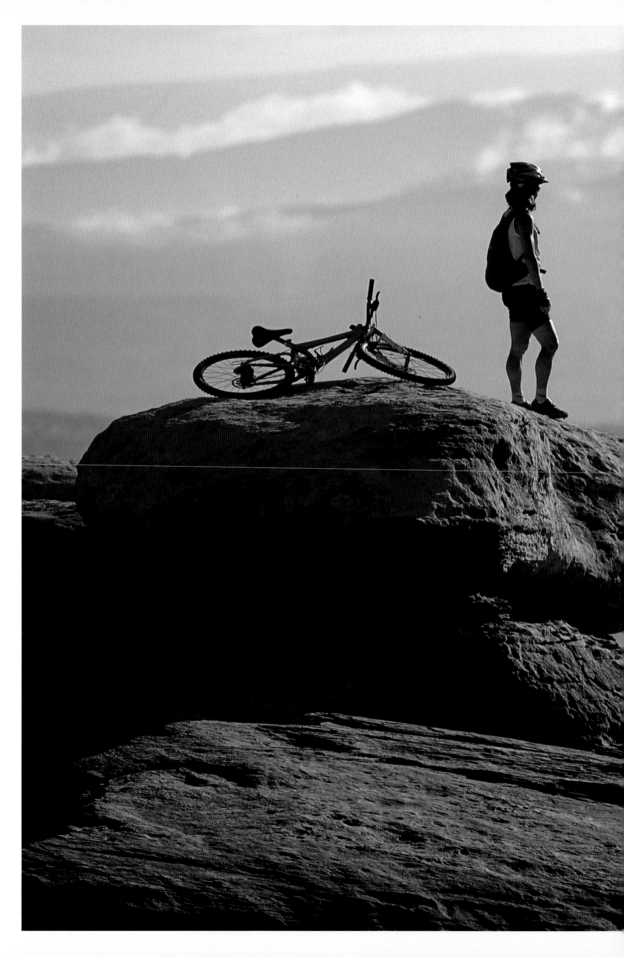

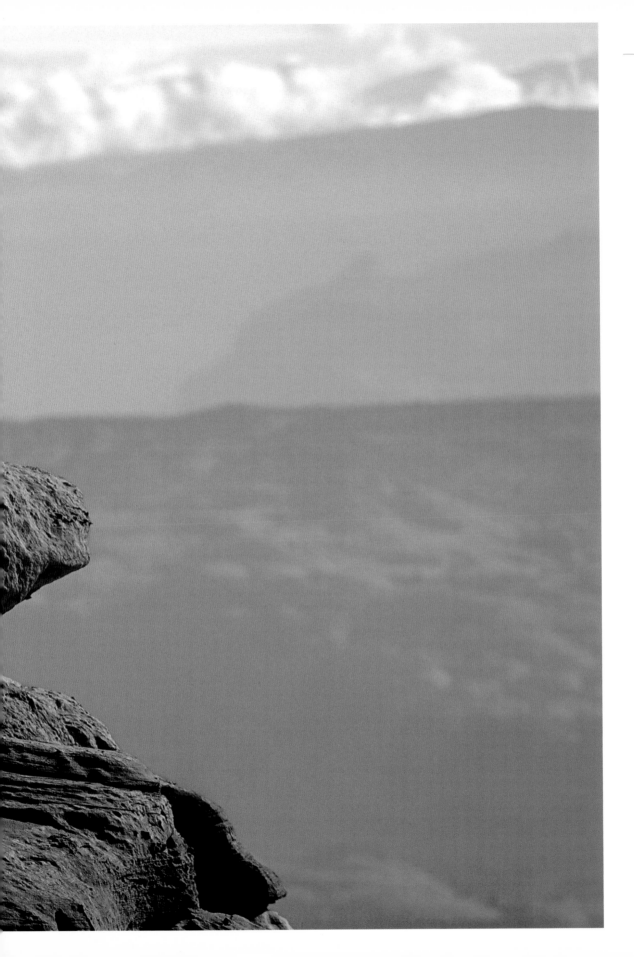

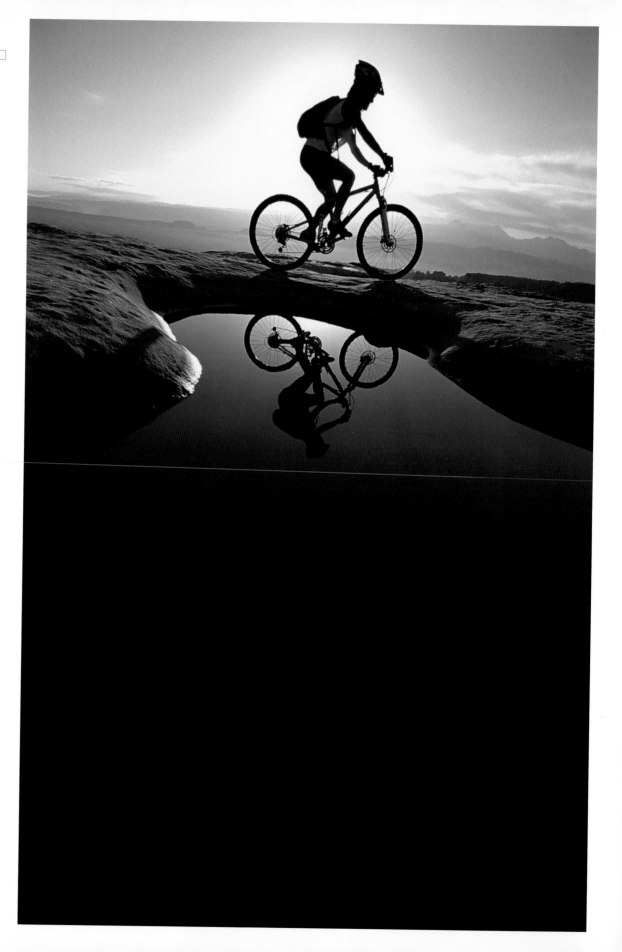

glance at the front and rear suspension of her bike, a sophisticated machine compared to her first one, she clicks into her pedals and heads for the trail. After a quick push through some loose sand and a sizeable crowd of other bicyclists, she carves along the beautiful sandstone that defines the region.

Riding on bedrock is unusual for anybody used to riding on dirt. Traction is remarkably good, limited only by the steepness of the rock (which usually causes rider error before traction failure). "It's amazing to see how much your tread sticks," Sara says as she pedals up a steep, off-camber slab of rock, while other cyclists dismount and push their bikes to surmount it. "Nowhere else in the world can you ride 100 percent of the time just on sandstone." And without logs, branches, or roots to trip a rider.

On the downside, falls are unforgiving on body and bike. Constant transitions in the angle of the rock, along with ledges and stairlike outcrops, require unwavering attention. "A lot of it is like rock climbing—it really demands your entire focus. A lot of the time you forget about what's going on elsewhere," Sara says with a smile. The rock climbing comparison is apt—at times riding Slickrock would feel better with a belay: A loss of balance could mean a tumble of twenty feet or more down a near-vertical slope onto bedrock. Most cyclists opt to walk certain sections to avoid tumbles.

Unlike a single track through the woods or a meadow, the Slickrock Trail entails multiple paths marked with either white paint (denoting rideable sections) or yellow paint (walking suggested)

on the rock. The trail and the paint were first put down decades ago by the off-roading pioneers who explored the area by motorized vehicle. Today, because of the near-constant traffic the trail receives, thousands of bike tires have worn tracks through the lichen that clings to the rock, making it easy to find one's way. Much of the riding involves cruising in a bike's middle chain ring, with the occasional "mad sprint up the steep sections in granny gear," Sara jokes. "It's all about momentum." Keep your momentum and the pedaling is kept to a minimum. Lose your momentum and you're forced to push hard up the steep sandstone pitches. Sara, an old hand at Moab, glides over these spots with nothing more than a weight shift and a gentle nudge of the handlebars. The true measure of a successful ride on the Slickrock Trail is not high speed; it's finishing with a minimal number of dismounts.

At the end of the loop, Sara isn't quite as worked as she was her first time, more than twenty years before. The full suspension has taken out many of the jolts, and she now understands that riding in the desert means bringing plenty of water. She weaves through the crowds back in the parking lot, already talking about her next trip to Moab. Swinging her leg back over the top tube, she steps off her bike, doubling her dismounts on this ride over the Slickrock.

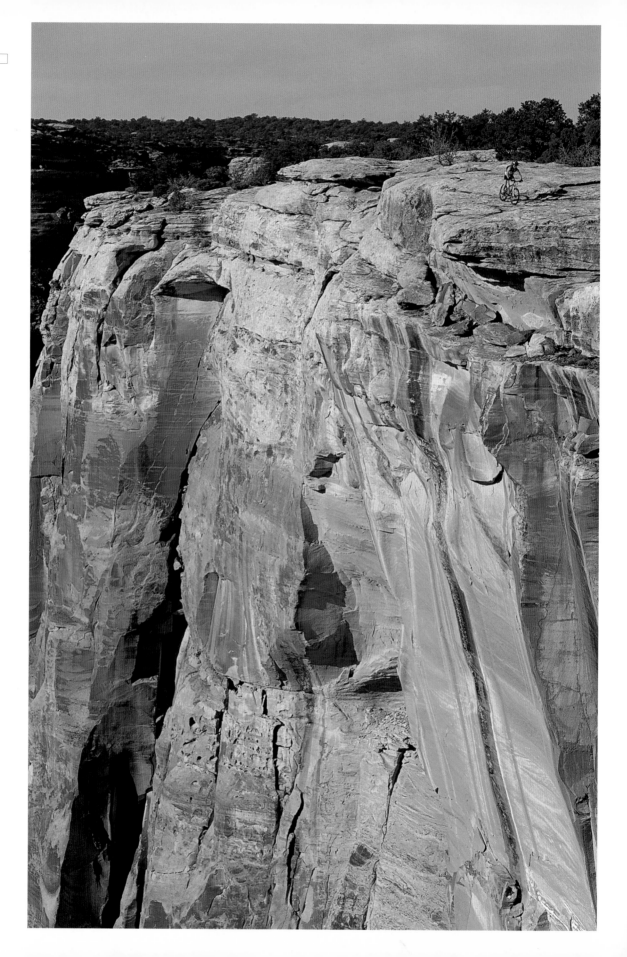

PHOTOGRAPHER'S NOTES:

THIS PARTICULAR SHOOT WAS FUN because I brought along a fifteen-year-old assistant, Max. I have known him and his family for years. Max had worked in our office helping out with all kinds of daily stuff and his dad had been asking if there was some way to take him on a real assignment. Max always displayed interest whenever I described a shoot or was planning my next adventure. Thinking back on the mentors I had when I was Max's age, I was excited about the idea of offering him a similar opportunity.

When Sara's shoot came up, I figured Moab would be the perfect scenario. It'd be a great venue in which to expose Max to the reality of adventure photography. Before we left I told his dad, "We'll spend a couple of hours driving from the airport to Moab, stay in a hotel for a few nights, go out and shoot some photos during the days, and then come home—no big deal." I guess I either have a bad memory or have just gotten used to the strain of my job, because it didn't work out that way.

We showed up in Salt Lake at 4 P.M. The three-hour drive to Moab was more like seven hours, through snow and rain, in a front-wheel drive rental car. We finally rolled into Moab around midnight, and because we were supposed to meet Sara in four hours, we just threw our sleeping bags onto the dirt and slept next to the car. I remember 4 A.M. coming all to quickly.

The hike to the location wasn't too bad, but Max had a brutal load—he was probably carrying half of his body weight in camera gear. We shot from dawn to dusk, and by dinnertime I could see Max starting to sag. We stopped in town, ate our third burrito of the day, and camped in a field next to the trailhead where we were to meet Sara at 5 A.M. the next morning.

The payoff came the next afternoon. Instead of taking a much-needed nap, we borrowed a couple of mountain bikes and explored. Max and I were totally blown away by the landscape around Moab and the unique feeling of riding on sandstone slabs. We still had to shoot that evening and then make the long drive back to the airport, but taking a few hours to have fun outside was worth it. We could sleep later.

On the way home, Max used my phone to check in with his folks, and I started saying, "Max, turn in here, turn right," like he was driving. I was teasing his dad, but I was so exhausted it was tempting to have him drive. Finally, at 1:30 A.M., I was too tired to keep going. We pulled about 100 feet off the highway into some gravel lot, and I told Max, "We're going to sleep here." He just looked at me. "Really? Here?" he asked. By way of an answer, I set my watch alarm. The backseat was full with gear, so I slept under the back of the car to be out of the rain, while Max curled up in the front seat. An hour or so later we were back on the road, and I realized that I couldn't send him home smelly and dirty, so I bought him a shower at a truck stop and then shoveled him onto the plane. He fell asleep before we took off.

When I dropped Max off at his house, his folks asked how it went. I gave them a straight face. "It was fun, we made great photos, Max did really well." A few days later his dad called me and said, "Max just slept for two days. What did you do to him? He said you were sleeping under the car and showering at truck stops..."

Well, his dad still speaks to me. Max is even more interested in photography, and we both had an amazing time. In the end, that's what counts.

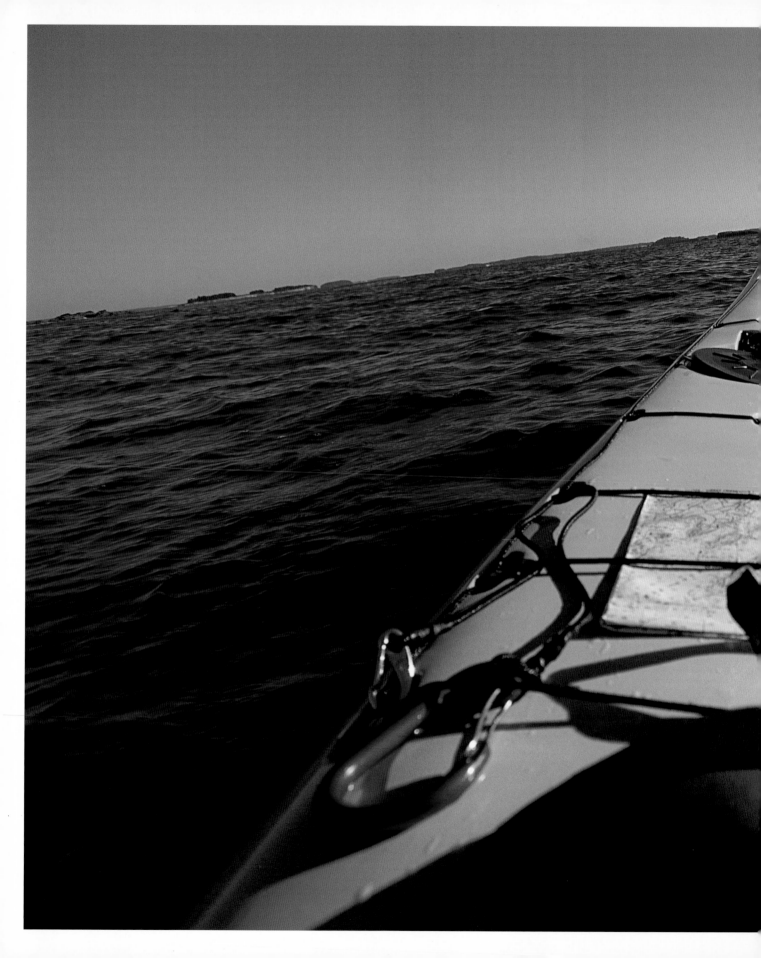

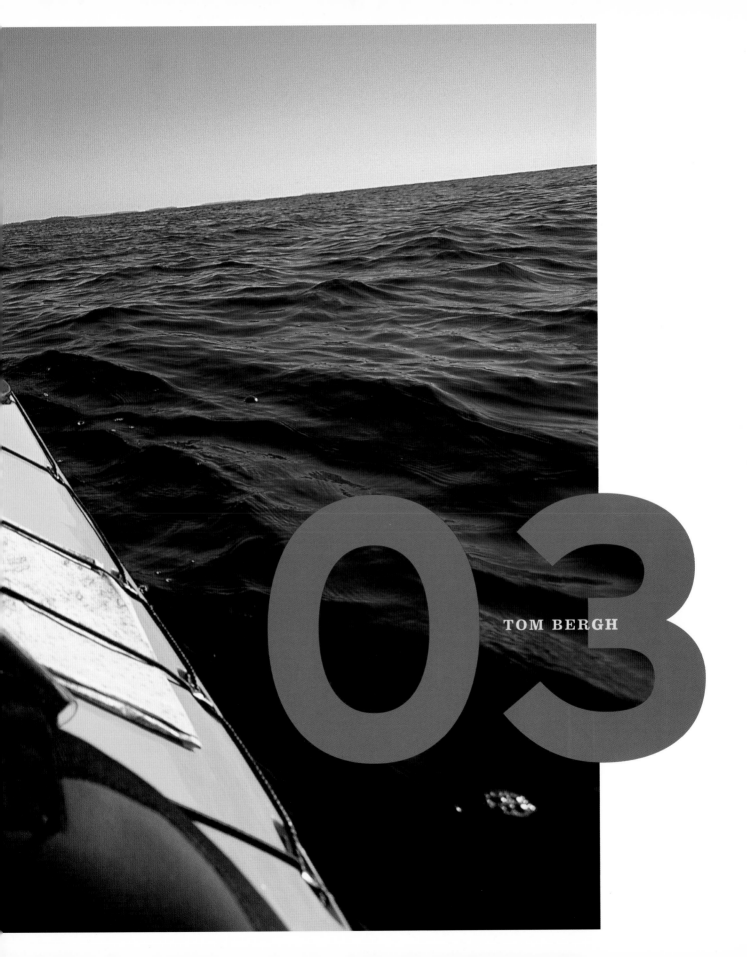

03

TOM BERGH

MY FAVORITE
PLACE

32

Page

ATHLETE	SITE	SPORT	LATITUDE / LONGITUDE
Tom Bergh	Peaks Island, ME	Sea kayaking	43°39'N / 70°12'W

Off the port side lies the mangled metamorphic shoreline of Outer Green Island, a bird sanctuary at the eastern edge of Casco Bay, Maine. Off to starboard, the rising sun gleams across the open swell. "If you were to paddle on," Tom Bergh says, looking to the east, "you'd hit somewhere around the Mediterranean, maybe North Africa." But Tom prefers, to stay close to shore; these islands are why he chose to live here. "It's a great place because there's so much shoreline," he says. "We have hundreds of islands in this bay, and a few thousand in Maine. It's just a phenomenal amount of variation."

Paddling through gentle surf, his hands make the occasional connection with the cold October water. Tom's thin, fiberglass boat whispers and thumps as it slices through the waves. The lower half of his body, sealed beneath a protective skirt of nylon, sits at the waterline. "I like to feel the bump in my butt," he says with a smile on his weathered face. "You feel the slightest change in wave shapes and currents; it's much more about a dance with forces that are way stronger than we are."

Tom joined the dance in the early 1980s, when he abandoned a decade-in-the-making Colorado law practice and returned to the East Coast, where he grew up. Settling with his wife, June, on Peaks Island, just off the coast of Portland, Maine, he quickly adopted sea kayaking as a way of life. "I immediately got it," he remembers. "This is an amazing way to explore the boundary of water and land." Today Tom is a sea kayak guide, sharing his enthusiasm and his ability with Manhattanites looking to escape the big city, veterans of deep-water sailing who want to investigate a different way to enjoy the ocean, and others. "Guides are a little bit like translators, bringing people into new places, new dimensions," Tom believes. "People learn to relax and say hello to themselves. Instead of nine-to-five, they're living based around

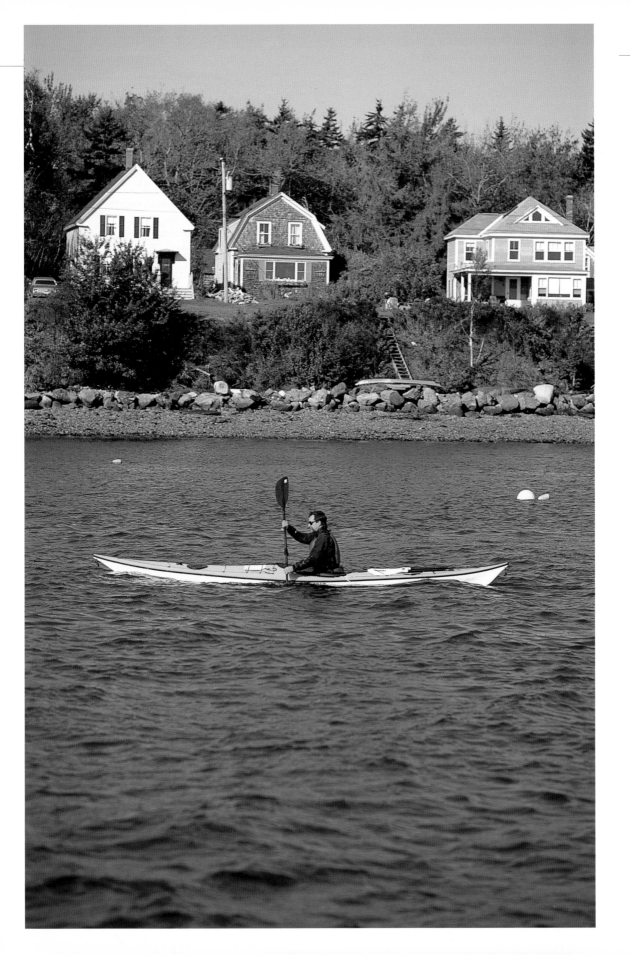

high and low tide. There is an allure in the fact that
the seas are connected around the world, that you're
in some sort of tremendously powerful energy form."
Tom has felt that energy paddling in the chill of Alaskan
waters, the warmth of Mexican seas, the historical
estuaries of Scotland, and the rarely explored waters of
Antarctica. "I like it because it is the essence of self-
reliance, of personal responsibility." That said, Tom adds,
"I think there are land people and there are water
people. I don't think sea kayaking is for everybody."

Tom is, of course, a water person, and
Casco Bay is his personal Eden. In ten minutes he
can slip into water, paddle around the south end of
Peaks Island, and run straight into the Atlantic. This
part of southern Maine comprises several tiers of
islands dictated by the folded bedrock that created
the inland waterways and landforms. Ocean swells
break on shallow shelves, island peninsulas, and rocky
outcrops. Bad weather and even hurricanes coming
off the ocean can force a paddler to seek calmer waters.
"The nice thing about Casco Bay is if there's a big
storm, you [can just] go in a couple tiers," he says.
With tides and fickle weather, "it's this fantastic
puzzle of factors that are changing by the minute."
The paddling possibilities continue up into northern
Maine, or "Down East" in local parlance (the coast-
line runs mostly east-west in this part of the state; to

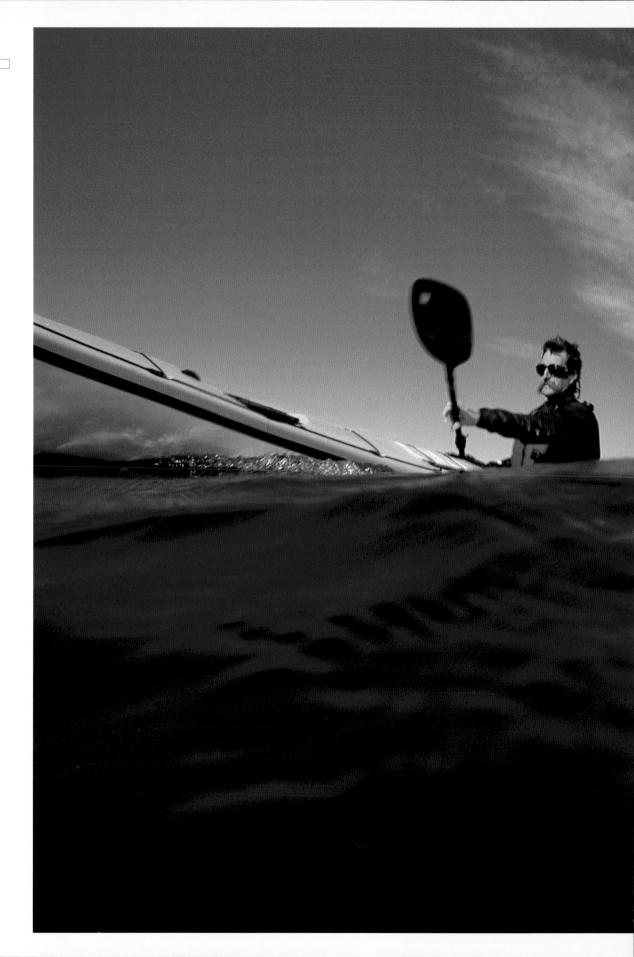

travel north you head downwind to the east). The choices nature provides—with the weather, water, and hundreds of islands—offer a lifetime of adventure.

Away from the wildness of Outer Green Island, paddling around Great Chebeague Island, Tom enters a sheltered bay where thousands of brightly colored lobster buoys bob in the light chop from the approaching storm. A lone lobster boat, its staysail holding the bow into the wind, pulls up to another buoy.

Turning a corner, Tom passes a rocky outcrop swarming with terns, and then a sandy beach framed by low cliffs and shadowed by spruce trees blocking the evening sun. In the interface between water and land, the rocks nudge the waves and the waves nudge the boat.

Admiring the scene, Tom says, "It's a dance. It's a dance where you use the ever-changing surfaces and movement of the water to play."

[PHOTOGRAPHER'S
NOTES:

IN PHOTOJOURNALISM THEY SAY, "Get there early and stay there late—that's when the best pictures happen." I've heard a million variations on this theme since I first picked it up at the *Antelope Valley Press* as a sixteen-year-old photo intern, and it still applies today. I've found that oftentimes the more uncomfortable you are, the better the pictures will be, because you're outside the time frames and settings of an ordinary day. You have to get used to crazy schedules, because photographers live and die by the light. Light is what we use to paint our pictures, and it's the difference between a great photograph and just a picture. So if I have to get up at 4:30 A.M. or stay out shooting until 8:00 P.M., sure, I'll miss out on sleep and a nice dinner, but I can sleep or eat anytime. To me the sacrifice is worth it.

We photographed Tom in his native Maine in the fall, and it was already brutally cold out there. I live in Lake Tahoe, California, and we get some real storms, deep snow, and adverse weather, but Maine is another deal entirely. It's a different kind of cold out there—the kind of wet, biting cold that seeps into you and makes you feel like you're never going to get warm again. For this piece, I was out on the ocean in a kayak, which added splashing water, totally erratic ocean waves, and extremely cold temperatures to the equation. To prepare, before I left home I paddled around Lake Tahoe a little bit. But it was all on mild chop with no swells or current, nothing like the ocean. I knew

it was going to get worse during the shoot. I brought three camera bodies with me and kept one packed away in case the other two died. I brought neoprene gloves so my hands wouldn't freeze, a drytop, a waterproof Lowepro Dryzone bag, an underwater camera housing—the whole deal.

Then I set about discovering the recurring patterns in Tom's world. Much of my job is just that, learning patterns—how people behave, what the weather does, how light changes through the day. When you see the patterns, you can predict what will happen next. You know that classic look of pure joy when a child opens a present, or how a dog looks when it leaps for a Frisbee? After a while, you realize that neither is a coincidence: the child is always going to be enamored with new presents, and the dog probably jumps like that consistently. My job is to anticipate the next time, and be ready to shoot it.

In this case, it meant learning the patterns of the ocean waves and knowing when to actually shoot to avoid soaking all of my equipment. It was all about rolling the dice and weighing the odds. I kept asking myself, "Is this shot worth killing a camera?" Some shots are worth it, absolutely, but the more I work, the more I realize that the best pictures come from being smart, not bold. Sure, I shoot adventure sports, but it's like any other business in some ways. You've still got to be smart, think intentionally about what you're shooting, have a plan, bring the right gear, and show up on time.

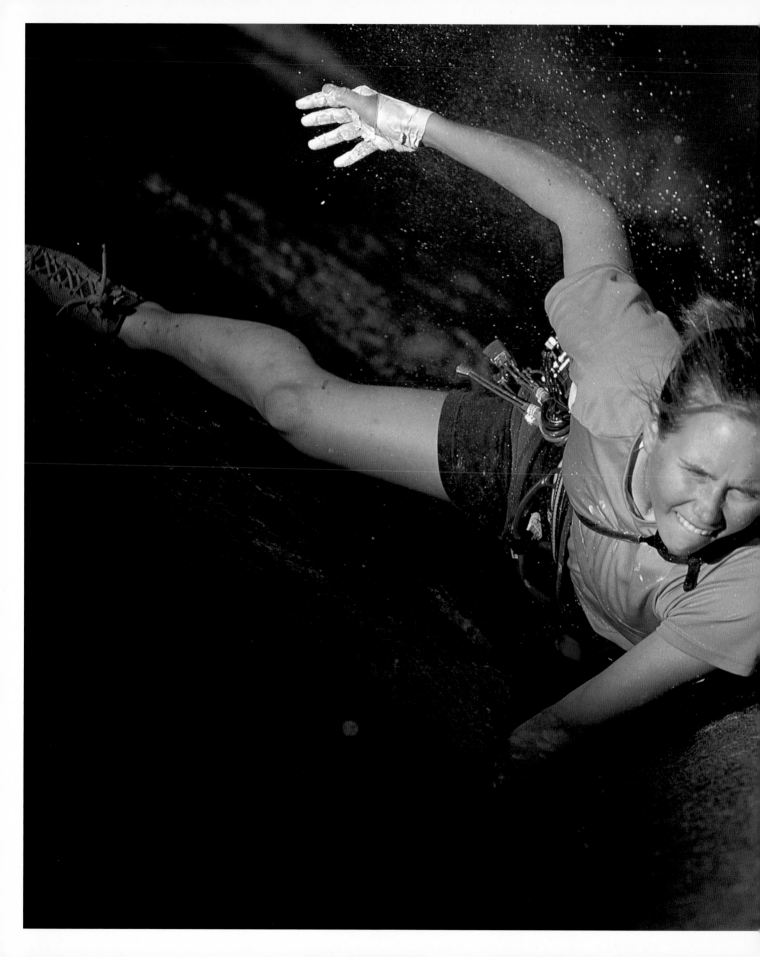

04

TOMMY CALDWELL
AND
BETH RODDEN

ATHLETES

Tommy Caldwell
Beth Rodden

SITE

Yosemite Valley, CA

SPORT

Rock climbing

LATITUDE / LONGITUDE

37°44'N / 119°38'W

Tommy Caldwell has fallen again. He's fallen many times on this small, nearly featureless section of granite on the West Buttress of El Capitan in Yosemite National Park, and it's painful. It doesn't hurt because he's falling far—he's dropping less than fifteen feet. The pain comes from the hours he's already spent trying to unlock how a sequence of moves can be strung together to negotiate this vexing piece of rock, where ledges look more like the edge of a knife than climbing holds. He takes a quick look at his fingertips, which, despite having thick calluses, are bleeding. He starts back up to the crux.

Along the way, Tommy examines the rock and marks small, individual crystals and irregularities in the granite with chalk. They're what he hopes to stand on, and they're too small to see from more than a foot or two away. But despite a body that is pure muscle stretched over a very lean frame, Tommy keeps falling, and his fingers are throbbing. "I don't know how many more tries I have in me today," he says with some frustration. "This really hurts." Half a rope length below, his climbing partner and wife, Beth Rodden, offers encouragement: "You can do it, Tommy." He takes a few big breaths. "Cliiiimmmm-mmbing," he yells, and reaches out once again to defy gravity's pull. His fingers are screaming.

This is only pitch 3 of 20 on the West Buttress route. Each pitch, each single length of rope alone would be a solid accomplishment for most climbers. On El Cap they are stacked one on top of the other for more than three thousand feet. No one has climbed all the pitches on this route without the aid of climbing gear to pull themselves up the cliff—Beth and Tommy hope to be the first to free climb

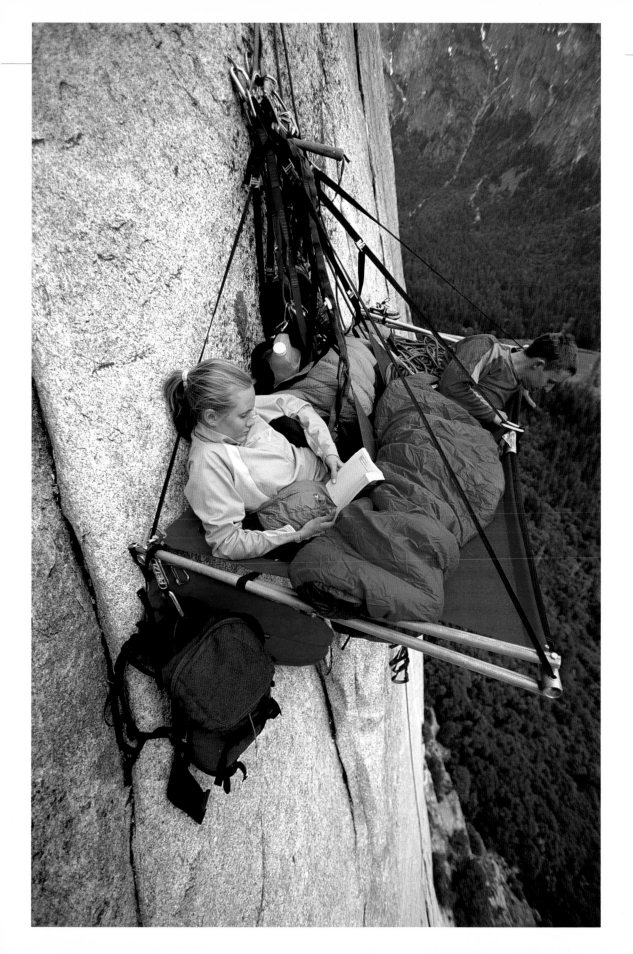

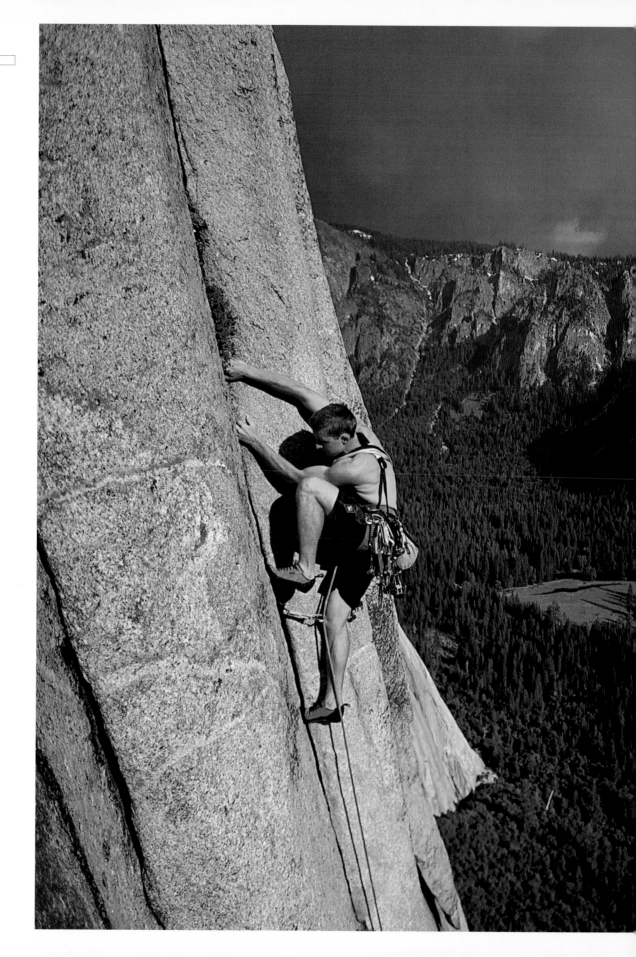

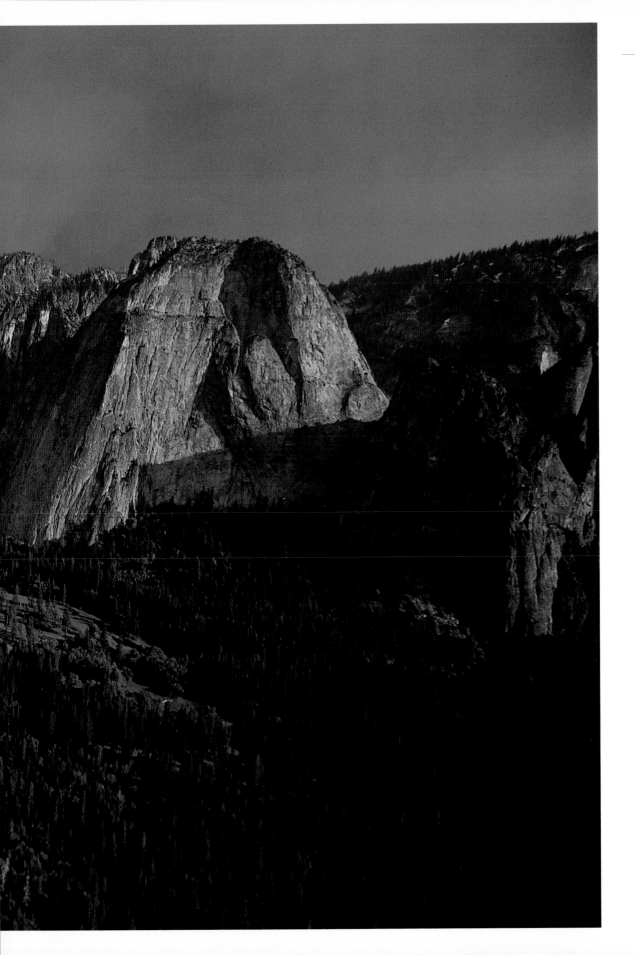

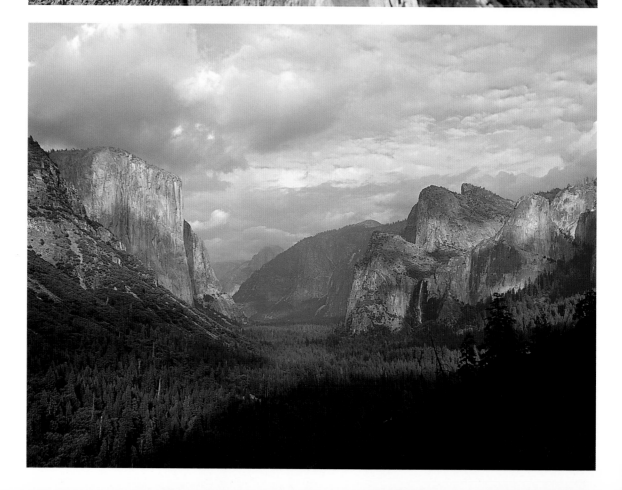

the West Buttress. But the blank spot on pitch 3 is the hard part for them; this is the section where they will spend a lot of time. Most of the other pitches, including the ones above, have already been worked out. "A lot of them are cruiser," says Tommy, meaning only 5.11 or easy 5.12.

The rating system for rock climbing was developed on the cliffs, including El Capitan, of Yosemite National Park, which offers dozens of first-, second-, and third-class hikes. The real climbing starts at fourth class. At fifth class, the system assigns difficulty in smaller increments, such as 5.9, 5.10, 5.11. A 5.15 is impossible, except for the very few climbers who reach Tommy's and Beth's level.

"Often a big free route can come down to one little section," says Beth. "You can have thousands of feet of climbing and spend all your time on a section that may only take minutes to eventually climb." The blank face on El Cap's pitch 3 is that crux section—it's "only" a 5.13 and therefore, in Tommy's mind, attainable. "I get the most satisfaction out of doing a route that is really hard for me," he says. "I love going out and doing a bunch of 5.9s and 5.10s, but that lacks the sense of accomplishment I get from doing a really hard route."

El Capitan rises more than 3,500 feet from the Yosemite Valley floor, and, stretching more than a mile wide, it makes even the most seasoned big-mountain veterans stare in awe. It is an ocean of granite. Polished by glaciers, it's smooth to the touch where it juts out of the ground at the base. "It's really solid; it doesn't break; it's so consistently good," Beth says. Tommy believes it's this quality that gives El Capitan the reputation as the best piece of climbing real estate in the world: "For climbers it's the

ultimate. It's big, it's committing, and there's a lot of history."

Most climbers ascend El Capitan in the big-wall style pioneered by the early climbers such as Warren Harding, Tom Frost, Yvon Chouinard, and Royal Robbins in the 1950s and '60s. They attached hardware to the rock and climbed up a rope attached to that gear. Today, however, a select few attempt these established routes "free," meaning they use no gear to aid their ascent. "It's like gold, freeing a route on El Cap," Beth explains. This is why she and Tommy return year after year. "It's like magic," she says. For these climbers, there is no hanging on ropes, no pulling on equipment. Only the strength of their fingers and feet keeps them on the rock. Free climbers can spend weeks, even months, on a single route trying to discover its secrets. Once the secrets are unlocked, climbers like Beth and Tommy can reach the summit in less than a day.

Though El Cap is more than a thousand miles away from their home in Estes Park, Colorado, it's where Beth and Tommy spent the weeks leading up to their wedding, planning flower arrangements and making dress choices suspended more than a thousand feet above the valley floor. It's also where they spent their honeymoon. "It's pretty much where we started dating, too," says Beth. The pair had spent only a few days hanging out with mutual friends when they first climbed El Cap together. They've known each other since they were teenagers on the competition climbing circuit. But in those days it was more about pulling hair and giving wedgies than actually wanting to spend time together.

That all changed on a climbing trip with friends in 2000. "I learned that Beth's next plan was to go to Yosemite, and I had tentative plans to go, but that pretty much firmed them up," he says.

After a few days of hanging out in the valley, the duo found themselves working on what would become their first free route on El Capitan, a route called Lurking Fear. "We spent twenty-four hours a day together trying to free that route," recalls Tommy. On their first dates, they were literally tied together. Tommy remembers the moment he figured out they had something going on. "Instead of sleeping head to toe on the porta-ledge, she laid down the same way I was," he says with a shy smile. "It was pretty exciting."

Since that first El Cap route, there have been many more climbs and, of course, a wedding. Six years later, they're still together twenty-four hours a day, rarely separated by more than a single length of rope.

It's late in the afternoon, and thunderclouds gather over the horizon at the top of the wall. The air smells like rain. Beth is getting anxious for her turn. Oftentimes she's the one doing the leading, but this time it's been Tommy, and after many hours of sitting in her harness, she's ready to climb. Grimacing under the intense pain of yet another attempt at pitch 3, Tommy suspends his weight from nine fingers (he lost his left index finger in a table-saw accident). His feet dancing for new positions, Tommy strains as he reaches over to grab a razor sharp edge. These are the same moves he's tried so many times before. And so many times the secret has remained locked. But this time the key works. Some more deep breaths, a final skin-tearing pull, and he's able to grab something big enough to rest on. It's a ledge just a bit wider than the thickness of a pencil. The route will go free.

[
PHOTOGRAPHER'S
NOTES:

——————

SHOOTING ON A BIG WALL IS very physically demanding and requires complicated logistics and coordination. We fix thousands of feet of rope and haul every necessary supply, not to mention actually climbing and shooting photos. Packing the haul bag is an art in itself; every ounce of weight counts, so you do your best to travel as light as possible. When your absolute necessities include food, water, sleeping bags, sleeping pads, climbing gear, headlamps, porta-ledges, and camera gear, you leave behind everything you possibly can, no matter how small.

The day I photographed Beth and Tommy was beautiful and clear, so Tommy and I decided to leave behind the extra cloths and the rain flies. Even though the forecast was calling for a slight chance of showers, Tommy and I knew that "chance of showers" in the Sierras usually translates to "no chance of rain." Beth disagreed with our decision and, with the strong voice of reason, reminded us that if it rained and we had no flies we would be screwed. She was overruled.

After a full day of shooting and climbing, we settled into our sleeping bags high above the valley floor on our porta-ledges. That night we ate dinner and shared stories. Tommy and I ribbed Beth about how light the haul bag was and how menacing the clear blue sky above us seemed. I took one last peak at the millions of stars in the night sky and said, "Damn, if we had brought the rain flies we could have used them as pillows." Tommy attempted to mask his laugh as a cough, but it was obvious. Even Beth let out a small chuckle and with all her calm and wisdom quietly uttered, "We will see."

We woke up at 3 A.M. to drops of water hitting our faces. Tommy and I had a short conversation and assured one another that the light drizzle would quickly pass. Instead, it quickly turned into a raging downpour. With no protection (e.g., rain flies) we had no choice but to descend two thousand feet on our fixed ropes in total darkness, while getting completely drenched by one of the worst storms of the season. Standing at the base, soaked to the bone, Beth didn't even have to say "I told you so."

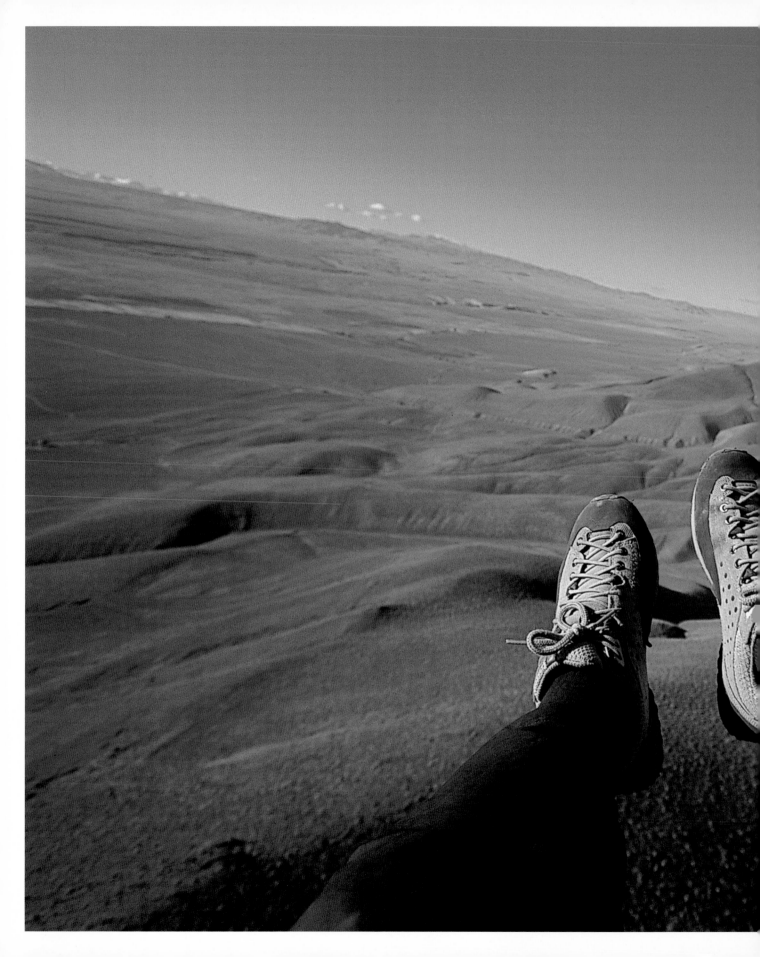

KARI CASTLE

05

"Oooohhhh, you see that?"

Kari Castle points to a few pieces of dried grass and dirt that swirl across the side of this small hill on the eastern flank of the Sierra Nevada Mountains. "A dust devil," she says. A dust devil, a miniature tornado of dirt and twigs, is what excites soaring pilots. It means the short drive and long hike from Kari's home in Bishop, California, up to the mountainside will pay off. A dust devil is the bottom of a thermal—a column of air shooting skyward—that will carry her paraglider high above the Owens Valley.

It's just past noon, and forty-four-year-old Kari, with her muscular frame and blond hair covered by a windproof suit and helmet, sweats in the October sun. With the focus of a hunter, she scans the bushes on the slope that falls to the valley floor some thousand feet below. She's looking for another sign, for a signal that it's safe to walk into the sky. "Here comes one," she says, watching the plants gently shake. In paragliding there is no perfect wave to paddle into, no deep powder to spray—only shuffling shrubs and the swirling dust to signal a thermal. Kari grabs the lines and lightly tugs the wing. Seconds later, a breeze lifts her paraglider over her head, and with a single step she's flying. She makes a slow turn to the right, seeking the invisible thermal that will take her higher. She finds it, turns in small circles, and minutes later is a speck in the sky above a dusting of early snow that covers the Sierras.

A native of Michigan, a location not known for its soaring sites, Kari took her first small hops off the ground in a hang glider in 1981. Her instructor at the time told her if she ever got into the sport, she should go to California. "I thought, yeah right, and a year later I moved here." A few years after that,

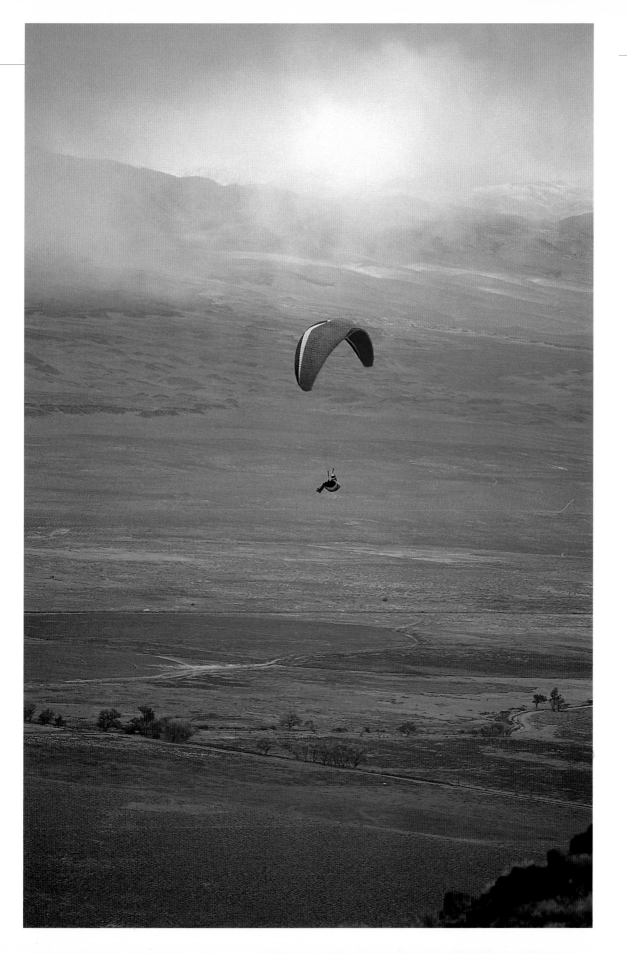

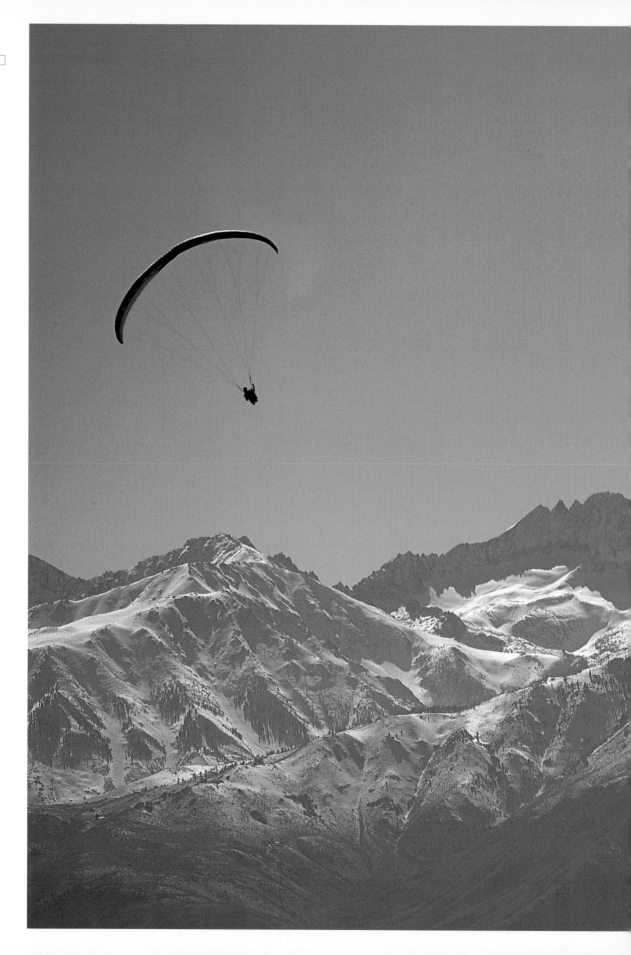

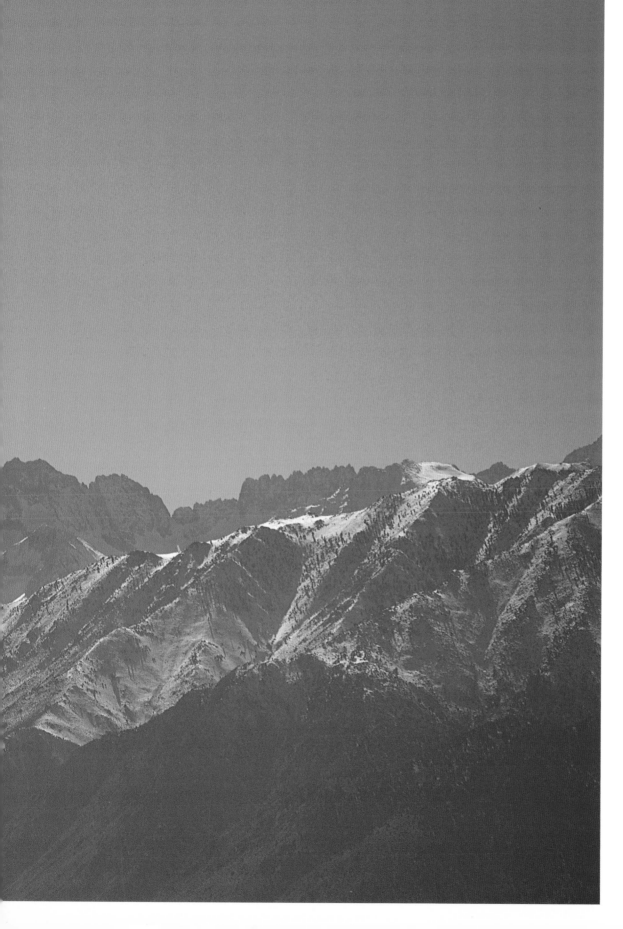

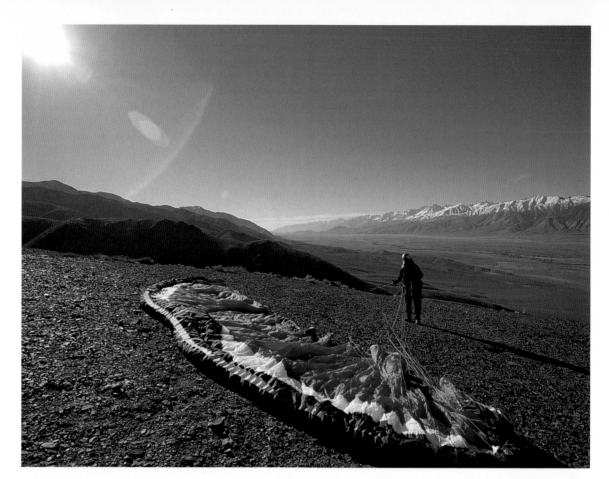

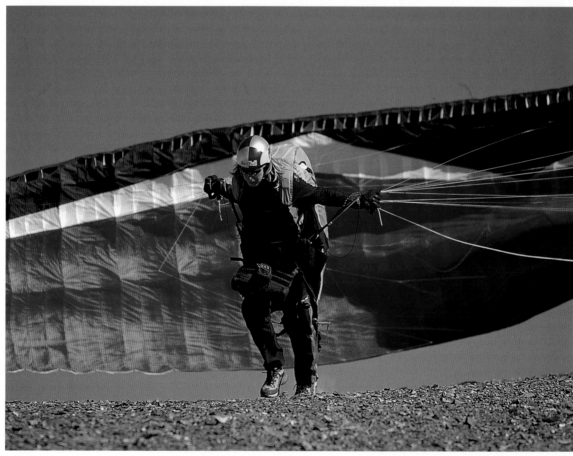

she won the very first contest she entered, the Silent Air Show at Milpitas Park, staying aloft longer than anybody else. "I pissed off a few of the boys," she says. Flying began to take over her life. "You couldn't keep me on the ground," she recalls of her early days. "I figured there was no reason to be on the ground if you could be in the air."

She continued to enter contests after settling in the San Francisco Bay Area. She entered her first national championship in 1988, and won. She went on to win several more national and world championships in both hang gliding and paragliding (she likes both forms of flying and alternates depending on conditions, location, and, most of all, mood). Now, Kari is considered one of the best paragliders in the world.

During her time in the Bay Area, she continuously heard about the Owens Valley. Sandwiched between the Sierras to the west and the White and Inyo Mountains to the east, the valley has long been a legendary place for soaring. Roughly a hundred miles long and ten to twenty miles wide, it attracts fliers from around the globe; even the best in the world speak of it with reverence. In one of her first competitions there, Kari discovered why.

"The air was pretty rowdy," she says. Sometimes thermals are like gentle elevators; other times they are like violent washing machines that demand full attention and a lot of skill. "I was getting tossed all around and I tumbled into my glider." Caught up in the lines and fabric, Kari plummeted toward earth. With the ground fast approaching, she had only one option: "I decided to throw the reserve chute." But the safety of the reserve doesn't guarantee a gentle landing, and she hit the ground hard. "I broke my tooth, my tailbone, my back and foot."

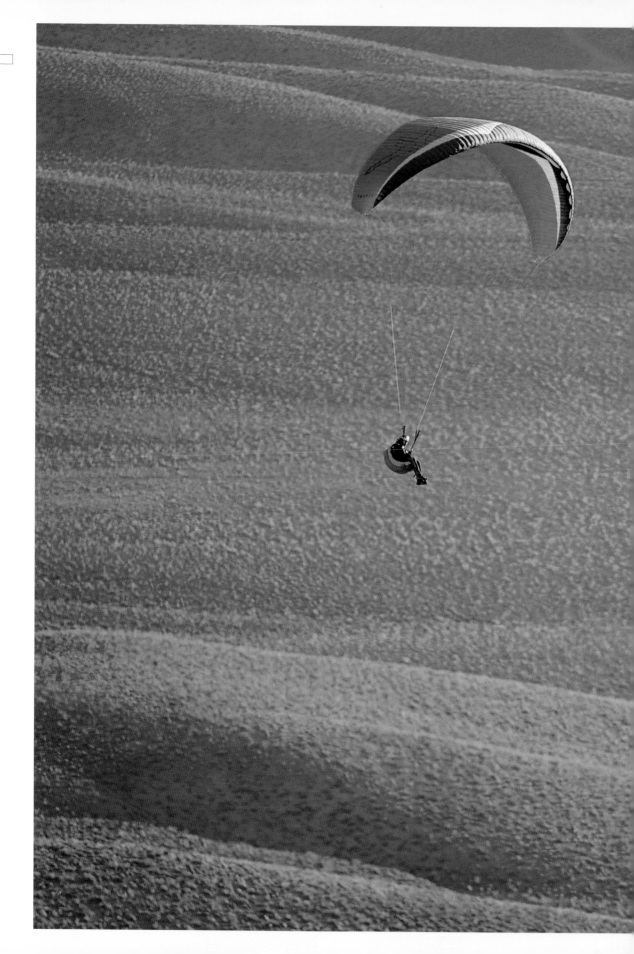

The experience changed her as a pilot. "It took me three years to get over it," she recalls. In spite of the accident, in 1995 Kari moved to the Owens Valley for good. "I tried the commute, but it didn't work. I called in sick all the time."

Today, Kari flies every day that conditions allow it, which is often here, where the mountain ranges enjoy a reliable supply of sun, which fuels the needed thermals. But she gives the potentially dangerous area the respect it deserves. "It has a reputation like the Pipeline for surfing—you're going to get the biggest and baddest stuff," Kari says. "I don't fly here during midday in the summer, when the conditions are the most turbulent. It's great in the fall, and I teach and guide people here all winter." Many visiting pilots are intimidated by the valley, she says, "but if you choose your conditions, there is a time and a place for amazing flying." Having paraglided all over the world, Kari understands why Owens dazzles many pilots. "It's about the altitude gains," she explains, referring to how high pilots can climb on the strong thermals, allowing them to work their way up and over the high peaks.

Ideal conditions are only part of the appeal for Kari. The flying sites scattered around the valley have yet to be domesticated. "There's no club managing the area, no permits. It's one of the few remaining truly free flying areas; it's still wild," she says. "You can just walk up and fly off; you can go anywhere."

When Kari touches down in a farmer's field just a few miles from her house, she calls her ride a good one. "It was a little messy up there at times," she says, describing a few turbulent moments. But it wasn't the bumps that ended the day. "I would have kept going, but I was getting cold."

[PHOTOGRAPHER'S
NOTES:

NO, I'D NEVER PHOTOGRAPHED paragliding, but I had put myself in extremely challenging environments for shooting photos countless times and always emerged successful. I thought, how could this be any different? At this shoot, I quickly photographed Kari from every conceivable angle from the ground: prepping her glider at the launch site, soaring high over the Owens Valley, then floating over the Sierras. The next logical step was to take to the air and shoot from her perspective. As Kari rigged a tandem harness that would allow me to fly with her, she quizzed me about my experience shooting photos in extreme environments, wanting to be certain that I could handle flying and shooting at the same time. I assured her it would be no problem.

The next thing I knew, our feet had left the ground and we were accelerating upward in a spiraling pattern. The feeling was amazing! I pulled the camera close to my eye in an attempt to somehow capture the sheer magic of flying. But something wasn't quite right. My face was getting hot and I was feeling really dizzy, and every time I tried to focus it got a little worse and I got a little more nauseous. At first I attempted to fight the feeling and just shoot photos, but it was impossible. I was definitely going to puke. I needed to get my feet back on the ground—and quickly. Kari was no rookie to this situation; she could tell that I was getting sick and loved it. "Please, can we go down?" I begged. Kari laughed, increased the speed of our spin, and calmly said, "Try and throw up to the side so that it doesn't get all over me."

We finally touched down in an open field where my assistant (who on this shoot just so happened to be my dad) was waiting to retrieve us. It took everything that I had inside me to avoid crumpling under the pressure of the landing. I collapsed whimpering into the dirt. Kari and my father, both thoroughly entertained by the scene, decided to document the moment. The next thing I felt was the strap of my camera sliding off the skin on my neck and the weight of Kari's foot on the small of my back. I opened my eyes just in time to see my father taking a picture (with my camera) of Kari standing victoriously over me.

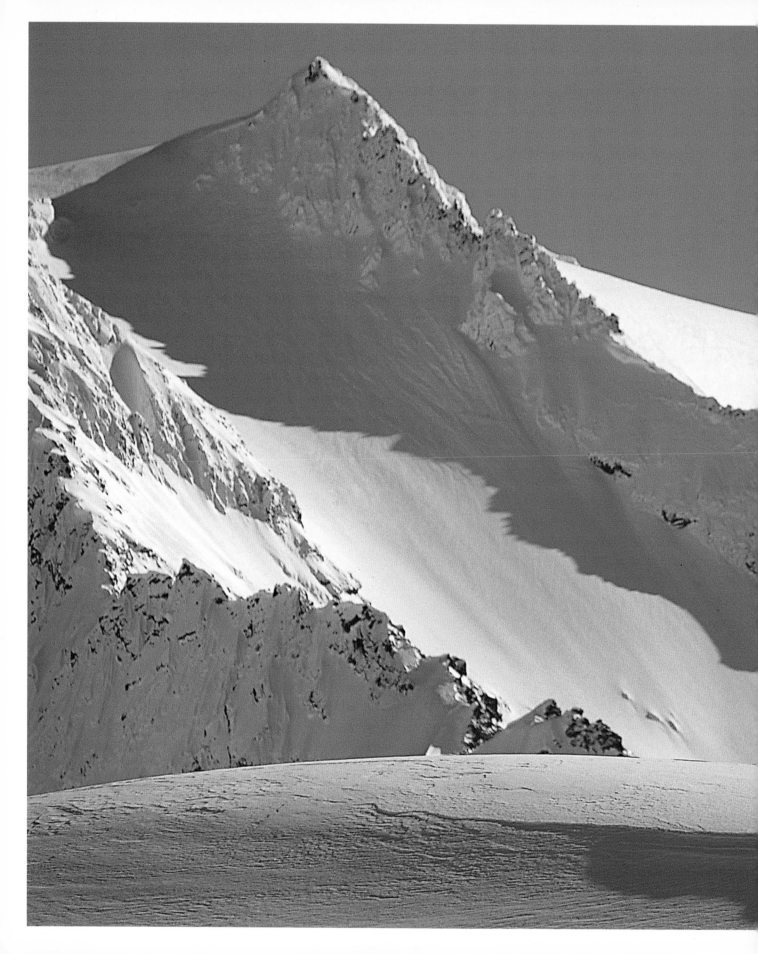

06

BARRETT CHRISTY

One thousand one hundred and forty inches of snow. Ninety-five feet of powder. That's how much snow fell at the Mount Baker Ski Area during the 1998–99 season, when the mountain claimed the world record for annual snowfall. That's one of the many reasons professional snowboarder and former U.S. Olympian Barrett Christy calls these slopes in the northwest corner of Washington home. "The main focus is the mountain," she says. "It's not the hotels [there are none]; it doesn't have a resort feel; it's the mountain."

Riding the lift over countless snow-covered stumps, trees, and rocks, Barrett explains what it is about the mountain that makes it special. "The lifts access some of the best terrain you can get at a ski area," she says. "There's a steep pitch to a lot of the mountain, lots of canyons and gullies. That's the great thing about Baker—the whole place is a terrain park."

Baker is currently in between storms, and new snow hasn't fallen in several days. Barrett shrugs off the conditions. "I've had some of my best days up here when it hasn't snowed in a week," she says, entering the backcountry through a gate off the top of the lift. "You just have to know where to hike to, little stashes here and there." Holding her snowboard behind her back, Barrett scans a well-established boot trail winding its way to the top of the narrow, exposed ridge. After checking her avalanche beacon and safety gear, she starts up the steep snow staircase, which, despite its being well trampled, she assures will lead to the promised land.

At the top, Barrett straps into her board. With her small, compact frame that belies her strength, she barrels down a section of the crest that features near-vertical drops and rock outcrops. With a simple and understated frontside air, she lands on a

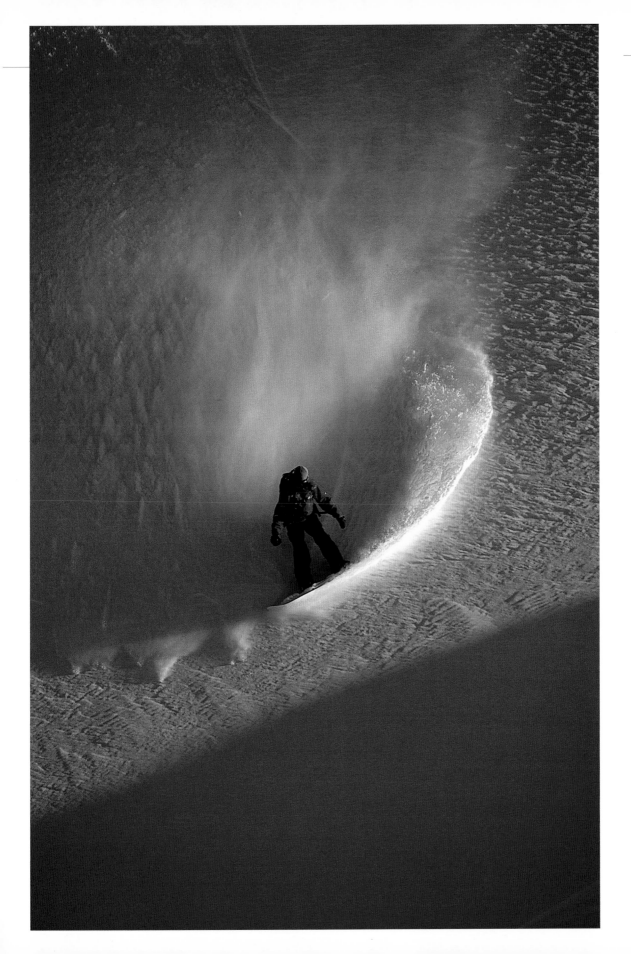

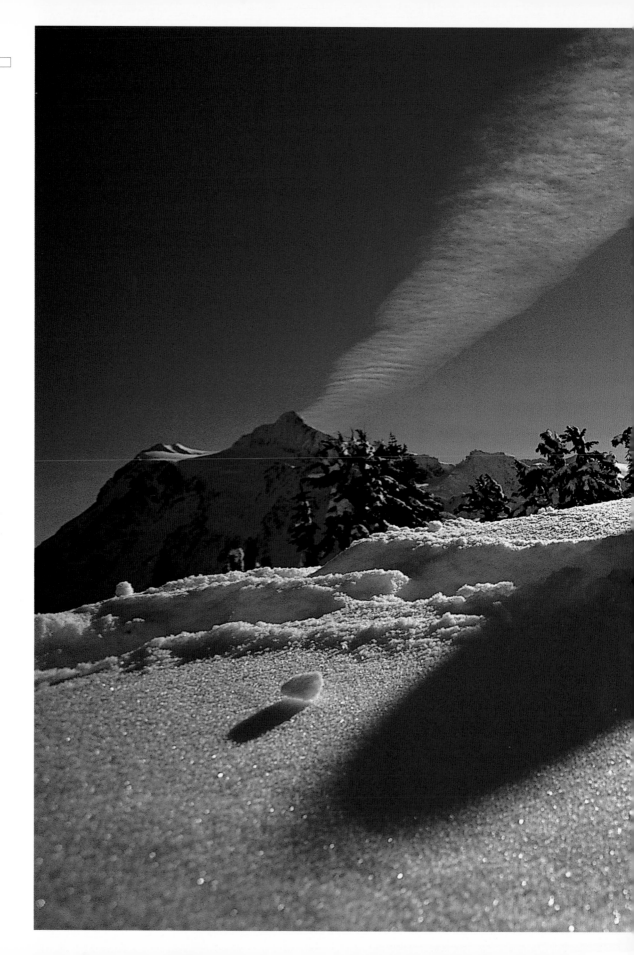

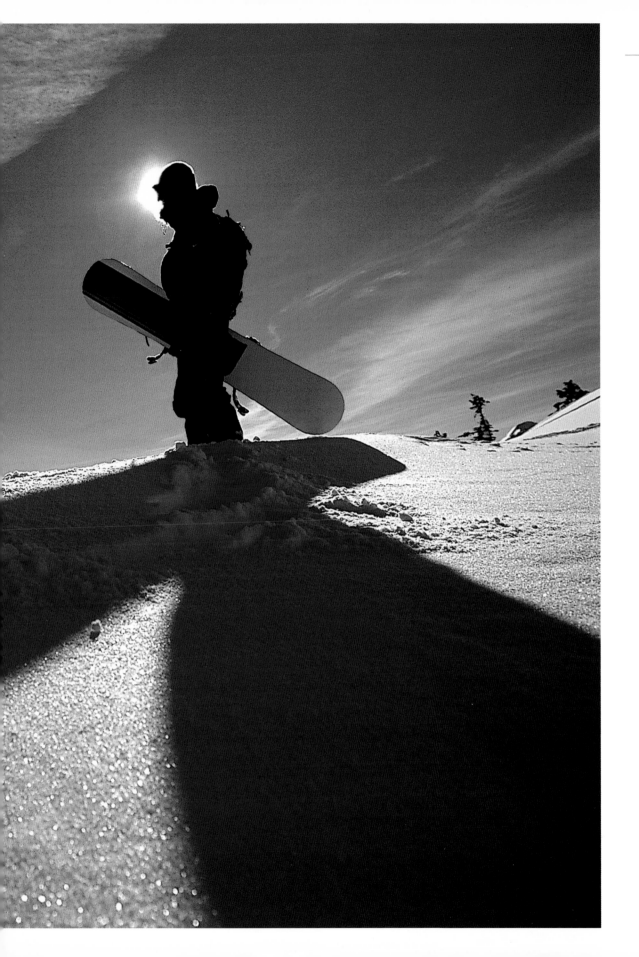

pillow-soft powder slope and executes a slow, drawn out toeside turn, throwing up a spray of snow. She suddenly comes to a halt and, with a smile on her face, kicks off her board and hikes up a nearby ridge, where yet another powdery route lies waiting.

Mount Baker Ski Area is not even on Mount Baker, which is the northernmost volcano in the state. Rather, it straddles a ridge on an adjacent peak called Mount Shuksan. Technicalities aside, for skiers and boarders who have frequented the family-run area since the early 1980s, it's simply Baker.

"It's always had a legendary reputation," says Barrett, a Pennsylvania native who first came here to compete in the Mount Baker Legendary Banked Slalom, the longest-running snowboarding event in the country. "To come out here and ride was a dream come true." Many of the sport's early pros, including the late Craig Kelley, were Baker locals who plied the slopes from early fall until late spring.

Barrett didn't touch a snowboard until she moved west after high school. "I had never skateboarded or surfed; it was my first attempt at standing sideways," she says of her first time out. Despite painfully cracking her tailbone on the first day on the slopes, she became determined to master the sport, which she saw as "much more effortless and graceful than skiing." She was hooked. Just a few years later, Barrett won the U.S. Amateur National Championship.

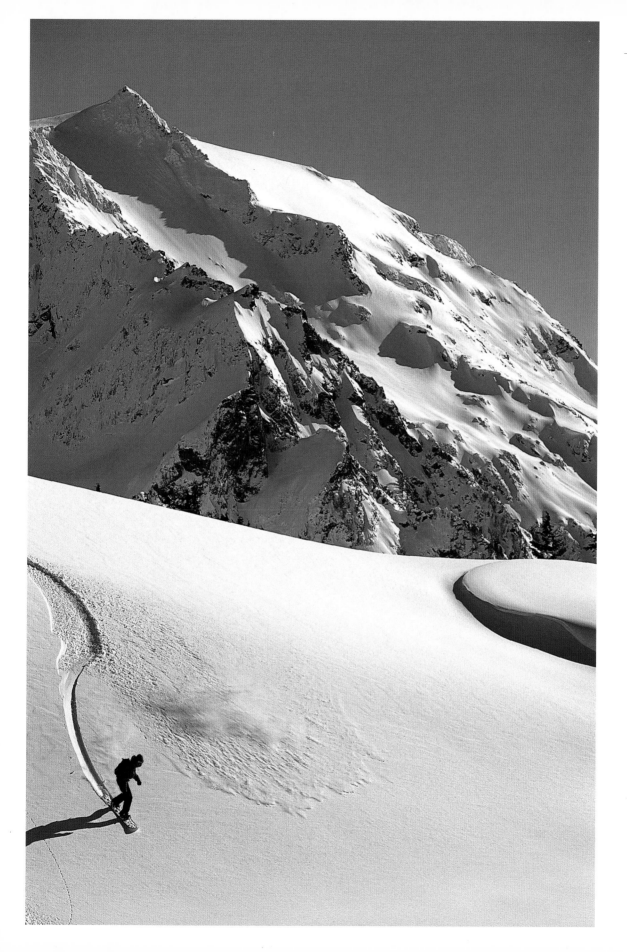

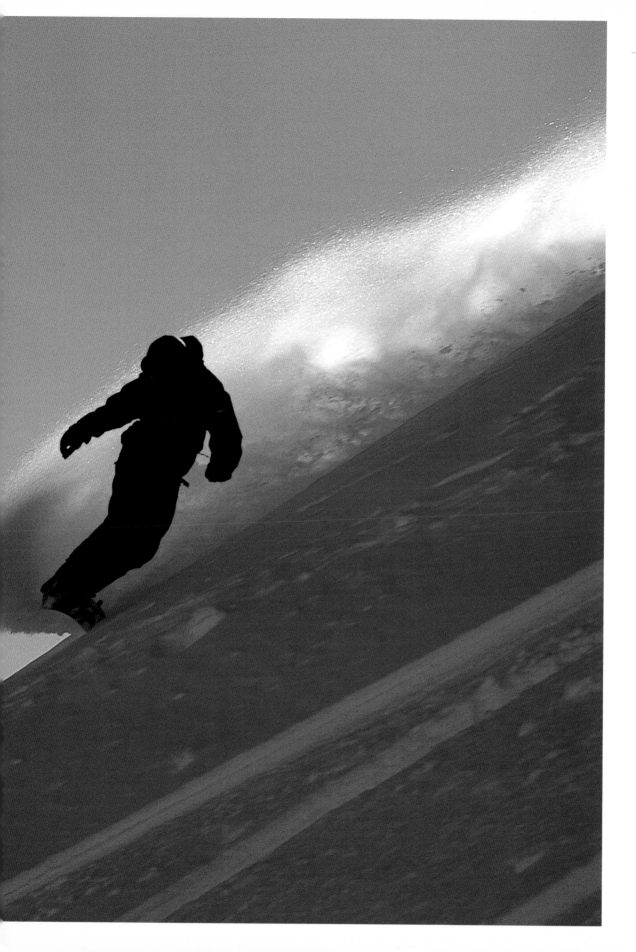

Soon after, she was sponsored, and she never looked back. Today, Barrett is one of the sport's most decorated snowboarders. In addition to competing as a member of the first U.S. Olympic Snowboard Team in the 1998 Winter Olympics, she has won more medals in the decade-old X Games than any other person. She has also won the Mount Baker Legendary Banked Slalom, her favorite accomplishment.

Barrett settled in Washington with her husband, pro snowboarder Temple Cummins, also a Baker regular, following several years in Colorado. After watching locals such as her husband and Craig Kelley ride the mountain, Barrett reveled in Baker's steep, constantly changing slopes. "People who grew up on terrain like that are good for a reason," she says. "They go elsewhere and [other] places look pretty mellow."

Barrett gleefully watches the winter storms roll in off the Pacific. When summer approaches, the mountain shuts down, but a lot of snow lingers. (Baker is often the first mountain in the country to open in the fall, and one of the last to close in the spring.) Which suits Barrett just fine. "I ride well into May," she says. "There's always stuff to do up there, as long as you don't mind hiking."

[PHOTOGRAPHER'S
NOTES:

OVER THE YEARS, I have learned a few hard lessons about shooting in winter conditions. From these, I've devised a checklist for myself, which I used for this shoot with Barrett, and which might also work for you.

1. Always keep your hands dry and warm. The best photo in the world could be unfolding, but if my fingers don't work, I'm not going to capture it on film. So when my hands even start getting cold, I take action immediately. Prevention is a thousand times better than treatment. The times that I've waited, it took hours to get my hands back up to temperature, and in the interim I was suffering unnecessarily—dropping film and batteries in the snow and missing photograph opportunities. I use a pair of North Face Wind-Stopper gloves—they're thin enough to let me change film and operate the camera's controls while still protecting my skin. Operating the camera while wearing gloves takes some getting used to, but it certainly beats getting frostbite. I then put a pair of heavy North Face mittens over the gloves when I am actually skiing or hiking, to allow my hands to rewarm completely. In case of a hand emergency, I keep two chemical hand warmers in my camera bag that can easily be slipped into my mittens if need be.

2. Use your lens hood. When I'm shooting in the snow, I'm always concerned about keeping snow off the front of my lens. Once the lens gets wet, it is *very* difficult to clean it while in the field. During windy storms, the hood isn't much good, so I keep the camera covered in the bag until I'm ready to shoot. Then, the instant I pull my camera out of the bag, I'll cover the front element by cupping my hand over it. My goal is to expose the lens glass to the falling snow only for the moment when I'm taking the photo. I always keep an automotive chamois cloth in my camera bag for wiping snow off both the lens and the camera, plus a small scrap of lint-free cotton cloth for the final cleaning and drying.

3. Use a good camera pack. When shooting skiing or snowboarding, I pack my equipment in a Lowepro Nature Trekker AW backpack. It's a very functional bag that allows me to carry one camera body with a 70-200mm lens attached; 15mm, 16-35mm, and 300mm lenses; a 1.4x converter; a light meter; film; extra clothing; food; and my avalanche shovel. It is essential that my pack fit and function well while skiing. In winter weather, I'm not out hiking to patches of wildflowers; I'm skiing in the mountains, in potentially dangerous conditions, so I need a pack that is both responsive and functional. When I'm shooting, I get in the habit of always zipping my camera pack closed so my bag doesn't fill up with snow when a ski accidentally (or intentionally) sprays snow while making a turn. A pack full of snow-covered camera gear will put me out of commission instantly.

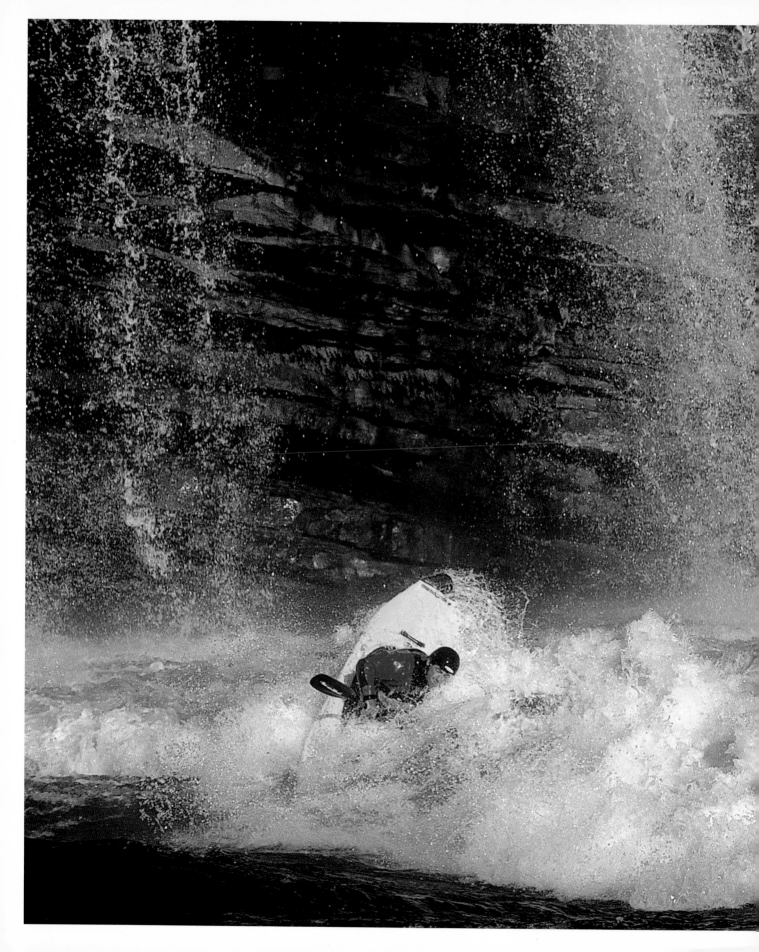

ERIC JACKSON
AND FAMILY

07

MY FAVORITE PLACE	ATHLETES	SITE	SPORT	LATITUDE / LONGITUDE
	Eric Jackson and Family	Rock Island State Park, TN	Kayaking	35°48'N / 85°37'W

78

Page

P

It's just after six A.M. on a cool fall morning, and Dad is impatient. Eric Jackson, or "EJ," as the kayaking community calls the former Olympian and three-time world champ, loads the boats into the back of the truck while the kids track down their spray skirts and helmets. After an obligatory sibling squabble over who gets to ride in the front passenger seat, the trio sets off on their morning commute—a three-minute drive to the soon-to-be-rising Caney Fork River. "The nice thing about the morning release," EJ says, "is I get a few hours paddling before the real-life stuff starts. I'm home at nine thirty, when most people are getting to the coffeemaker at work."

At the parking lot, kayaks are tossed onto the ground, heads and arms are squeezed into neoprene gear still a bit wet from the day before, and talk of the morning's plan begins.

"I'm going to try the seal launch by myself," thirteen-year-old Emily Jackson announces, referring to an entry where the kayaker slides like a seal off a slope into the water below.

A siren breaks the still morning air, signaling the opening of the gates upriver at the Great Falls Dam. It is this daily ritual that drew the Jacksons to rural Tennessee, far from any outdoor-vacation headlines. After living out of a motor home for five years, traveling from one kayak spot or event to the next, EJ and his equine-loving wife, Kristine, looked for a place to settle down. The requirements were simple: world-class paddling close to home, and room for the nonpaddler's horses. Rock Island State Park, a swatch of rolling hills and small canyons along the Caney Fork, a couple hours southeast of Nashville, won easily. Because of the water released by the dam, this section of the Caney Fork is extremely reliable, EJ says. He explains that many paddling areas, especially in the West, are dependent on snowmelt or rainfall, making them mildly predictable at best. "If you had to close your eyes and point to a calendar, on that day this place would be in the top three of anywhere in the country." The Jacksons bought a

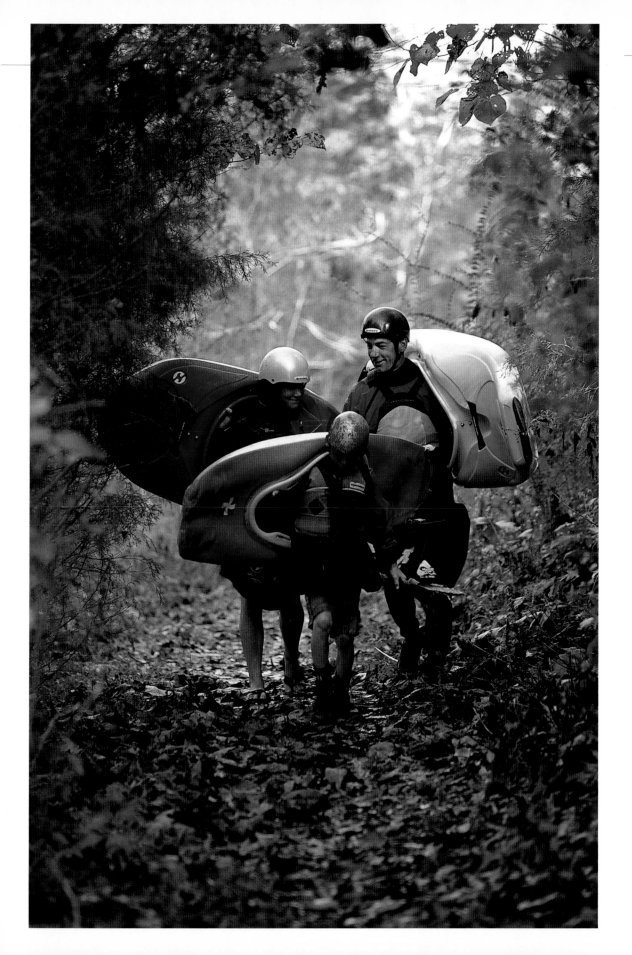

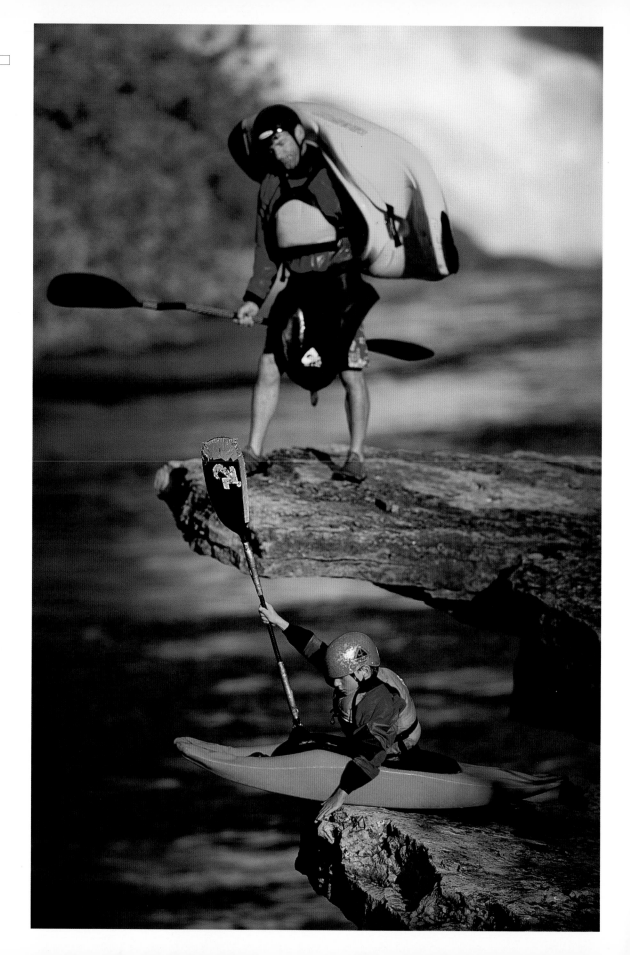

piece of property abutting the public land, just a mile-long drive to the white water. "It alleviates the stress of being home and wanting to go away all the time," EJ says. "And when you do travel, you know when you get back it's going to be good."

And for a kayaker raising a family, Rock Island has given EJ a place where his children have had a chance to learn. "The kids were super-motivated to paddle once we moved here," says the proud father. "The majority of their learning came here." Both Emily and ten-year-old Dane are constantly working on new moves, and they compete on the U.S. Junior Kayak Team together. EJ couldn't be happier that his kids enjoy hanging out with Dad every chance they get. "The kids pretty much paddle every time I paddle; I can't walk out the door to go kayaking without them wanting to go."

The three of them shoulder their small plastic kayaks, known as play boats, and maneuver down the slope, past a sign that reads DANGEROUS WATERS to a limestone outcropping above the river. EJ seal-launches first, popping out of the rising water after a twenty-foot drop. Not to be preceded by his sister, Dane is ready to drop into the river next. Sitting in a one-of-a-kind kayak made for his tiny sixty-pound frame, he rocks and hops his way to the limestone's edge. Teetering on the lip, he prepares for the drop. Dane's not yet a teenager, but he can already outpaddle most people on any river he visits. But as he gets a look below, there's a moment of trepidation: "Dad! Wait! I've never done it this high."

"Yes, you have," comes the encouraging reply.

"No, I haven't," Dane yells. "Not that I ever need you, but I think you should be down there!"

EJ paddles closer to the drop-in point. With a slight hop and a lean, Dane falls bow-first into the water. "Awesome!" yells EJ, with the enthusiasm of a kid watching his best friend. Moments later, Emily slides in with equal praise, and the three make their way to the "hole" just downstream. Unlike traditional white-water kayaking, where the point is to completely navigate a section of river, many of today's "boaters" prefer to find a set of rapids, or better yet, a single wave or hole (a place where smooth-flowing water is pushed under turbulent water being formed just downstream). Here they can take turns practicing flips, rolls, and spins in every contortion and combination imaginable.

EJ uses his powerful upper body to dig his kayak's bow into the wave face and executes a front flip, or air loop, out of the water. Emily spins several bow-to-stern cartwheels before getting flushed downstream. As she paddles back to the hole, Dane attempts an air loop but lands upside down and flushes. He rolls and resurfaces with a smile.

After an hour, the dam closes, the water level drops, and the hole reverts to a ripple before disappearing altogether.

Back at the truck, the kids squeak out of their gear with expertise. Quietly, with just a bit of shivering, they slip into dry clothes before piling in for the ride home, where their school day will begin (both children are home-schooled). A math quiz awaits Dane, and he needs a good score to get a kayaking pass for the next white-water session. Emily checks the dam-release schedule online. "Are you going in the afternoon?" she asks. "It says the water runs again at four o'clock." Dad needs little convincing.

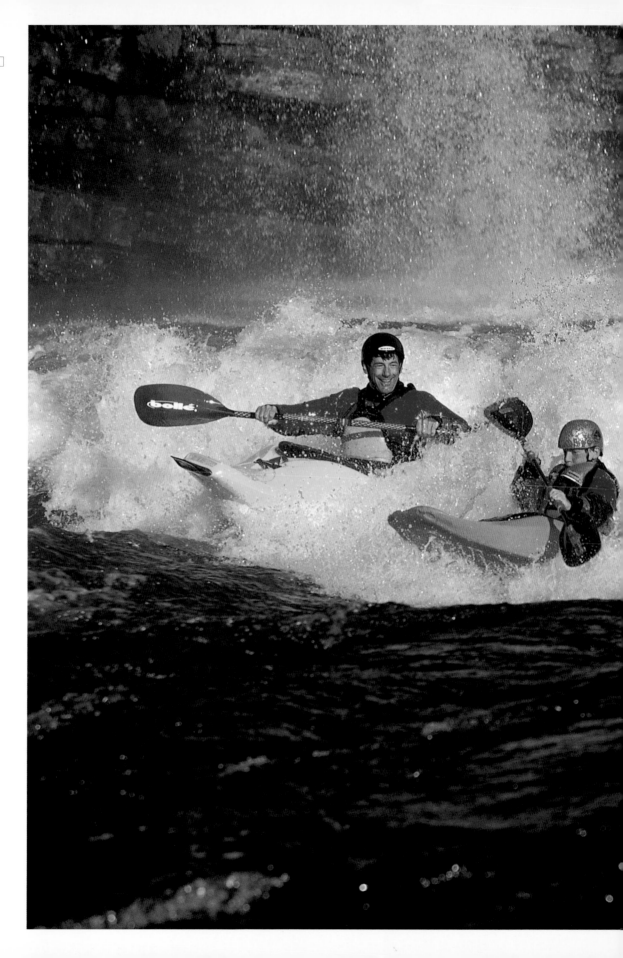

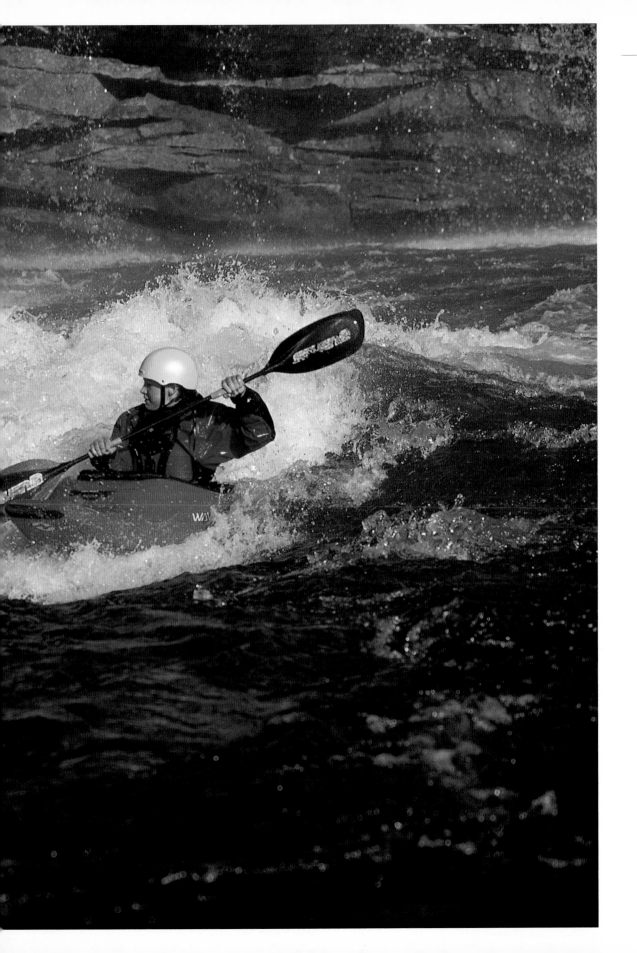

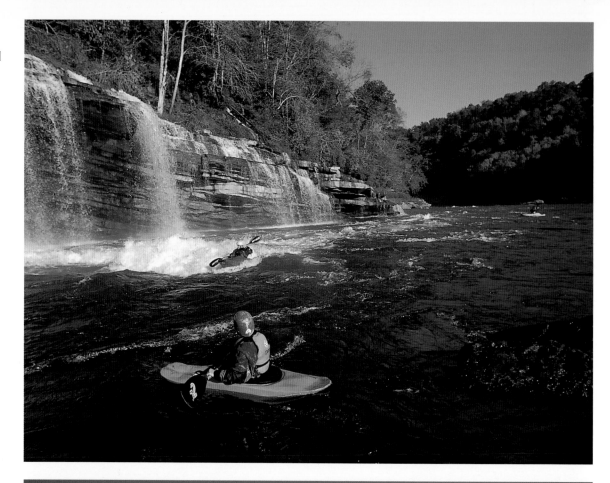

PHOTOGRAPHER'S NOTES:

ERIC JACKSON WAS THE FIRST ATHLETE Jason and I asked to be part of this book, and we had no idea what his, or any of the other athletes', answer would be. These are very busy people who are constantly training, competing, working with the media, running their businesses, and taking care of their families. We were a little anxious about how they would receive the idea of a photographer and a writer showing up and hanging out with them for a few days.

As it turned out, Eric was incredibly open and welcoming. He basically threw open the doors to his life and waved us right in. He insisted we stay in his house, because "the hotels are too far away and you'll get a better sense of us if you stay here, anyway." He kicked his kids out of their bedroom—they slept in the living room—so we could have their bunk bed.

The Jackson family was totally inspiring to me, especially in the way they had found balance. I spend my life looking for the perfect balance between work, play, family, friends, and down time. It seems like they're all kind of competing against each other. Yes, I'm outside in wild places, taking pictures of amazing people, some of them my best friends. That said, a job that requires being away from home two hundred days a year makes everything in "normal" life really challenging. For me, finding the time to mow the lawn and keep my house clean is difficult.

When I met Eric, right away I thought, here's a man who has both a successful, busy life and a happy family. How does he do it? He's even busier than I am, and he's pulled in more directions because he has a family. I wondered, is it all for show? Are they acting upbeat because we're here, or is he really this busy and this happy? It wasn't all for show. In the couple of days we spent together, I got to see the most functional, loving family in the world—Eric's three best friends are his wife and their two kids. Three out of four of them are world-class kayakers who love to practice the sport together.

In a way, it was perfect that the river was dam-controlled and the water released on a schedule, because I knew exactly which hour we had to nail the photos. On the days that I was there, at 8:40 A.M. the whole house would shut down. We'd stop in the middle of whatever we were doing, load up the car, race to the river, and, at 9:00 A.M. exactly, the water would start to come up. I'd run as much film through the camera as I could, and then we'd pack it in. It was the "hurry up and wait" game, but it made for great pictures because nothing had to be set up or staged.

Between kayaking shots, Jason and I were just hanging out with the whole family, and it was like being a kid again—we'd go to the rope swing at the swimming hole, fly Eric's model airplane, have lunch, ride bikes, and lie on the floor after dinner and watch movies. In a way, Eric's like a big kid, too—a very responsible, smart, business-savvy kid—whose whole schedule is about having as much fun as possible, all the time, every day. Meeting the Jackson family really confirmed that you can find a balance. For Eric, it's all in sync somehow. I hope someday I get it figured out as well as he has, because, honestly, that's as good as it gets.

08

SCOTT JUREK

88

Page

Efficient. In a word, that is how to describe Scott Jurek's running motion. Every movement he makes gracefully propels him with a minimal waste of energy further along a mountain trail at the base of Cougar Mountain, outside Seattle. His body contains a certain stillness despite a pace that would leave most runners far behind. He sheds a vest midrun with such ease that he doesn't miss a step or lose his rhythm.

Effortlessly he hops over an alder tree lying across the trail. He bounds up a short, rocky incline with the sure-footedness of a mountain goat. It's this kind of efficiency—this kind of ceaseless, uninterrupted movement—that has brought Scott to the forefront of his sport of choice, trail running.

Ultramarathon running, unlike its shorter, 26.2-mile namesake, doesn't utilize a standard distance. Generally the races are anything longer than a marathon; they usually begin at fifty kilometers (31.07 miles), move up to fifty miles, and commonly stretch for one hundred miles. One-hundred-milers, where finishing times under twenty-four hours are a badge of honor, are perhaps the best-known races. Scott prefers the one-hundred-miler, and it's where he excels. "I wasn't necessarily the fastest 50k runner," he says, as if they were sprints, "but I started realizing these hundred-milers might be my forte." This epiphany came after he finished second in the Angeles Crest 100 in Southern California, his very first hundred-miler. "The next year I won the Western States," he adds nonchalantly, referring to the premier event in the country.

The Western States Endurance Run, or Western States 100, invites competitors to ratchet up more than eighteen thousand feet of cumulative elevation gain in the high mountains near California's

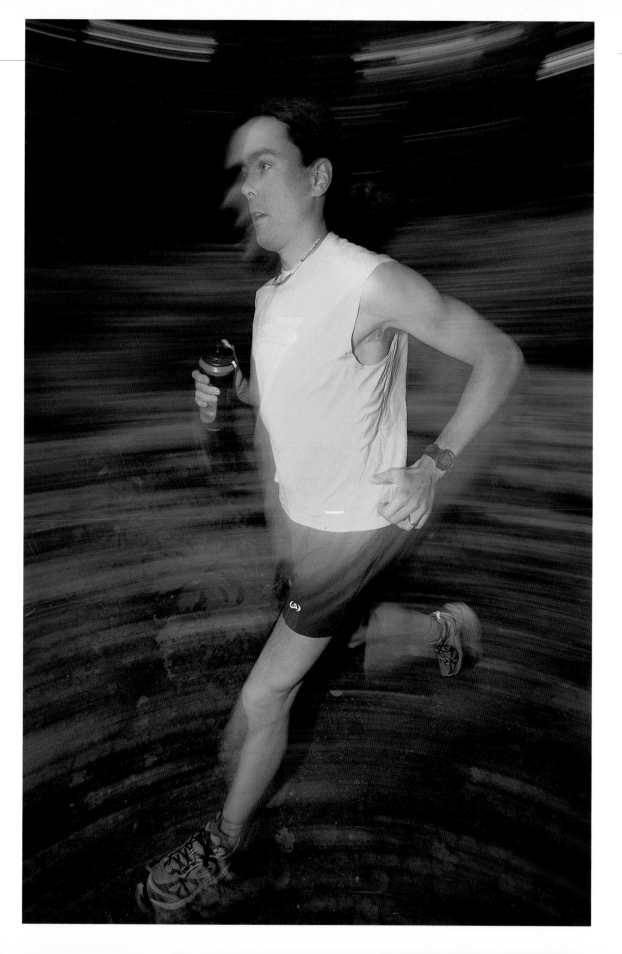

Lake Tahoe. Scott is a seven-time consecutive winner, with a course record of fifteen hours, thirty-six minutes, and twenty-seven seconds (an average pace of about 9:22 per mile). Scott sees through the race wins and records, however. "It's a vehicle to challenge myself every year," he says, "and I learn something every time I go."

Ultramarathons demand a new training mindset, a program most people would either chuckle at in amazement or stare at blankly in disbelief. Today, Scott is in a low-mileage part of his training schedule and will be out on the trail for only an hour—he rarely runs less. Later in the year, as the racing season approaches, his training time will increase. Four- to six-hour runs several times a week will become standard. To win a race like the Western States 100, physical strength is not enough. Scott says that at ultra distances, mental training can be just as important as physical preparation. "For me, that's where the difficult part is," he says. "You learn how to shut off that mental noise that your body keeps playing over and over and over."

To mentally prepare for the experience of racing for ten or fifteen hours, Scott has to reach similar levels of exhaustion in his training, and then keep going. "I'll do Mount Si repeats," he says, referring to one of his training routes in the Cascade Mountains. Mount Si is a popular hiking peak in the region, and for most it is an accomplishment to scale it once a summer. For Scott, the 3,100-vertical-foot, eight-mile round-trip to the top and back—three times in a row—is a regular part of his training schedule. "It's tough physically, but also mentally, to get done with that first one and then realize you're going to do it all over again, then a third time." It's a battle against the urge to quit, Scott says.

The Minnesota native runs many training routes throughout the foothills and peaks of the Cascade Range, and he feels a deep connection with the hundreds of miles of ground he covers. "I like it out here because it offers so much variety," he says. Whether running above tree line on the alpine ridges around Mount Rainier or trudging through the mud on a path in the rain-soaked forest, Scott says the most important thing for him is a connection he feels to the ground—"just being on dirt, feeling the energy of the earth." It's a connection he believes carries him further, something on top of the lungs, the legs, and the mental ability to turn off the pain.

Some might say he runs too fast to enjoy anything—how can he enjoy the place when he's running the entire time? "It's not always about the views," he responds. "A lot of the time, you take in the smells, the silence." He quotes the Tarahumara Indians, a tribe from northern Mexico whose members are renowned for their ability to run incredible distances: "When you run with the earth, you can run forever."

With a careful and deliberate stride, Scott steps his way across cobbles in a small stream near the end of his training run. This is about easy maintenance, keeping a base mileage so when the training does get difficult, his body will be ready. But there isn't a run during which he isn't concentrating on some aspect of what it takes to push the limits of ultramarathoning. "I'm constantly checking in with my body, making sure I'm staying efficient," he says. "Over the course of a hundred miles it's easy to lose seconds, even minutes." Scott's focus is underlined by his belief that running is "such a pure activity," he says. There's simplicity in what he does, and a lack of complications or distractions. As he says, "it's not something you need equipment for—it's just this natural form of locomotion, simple transportation."

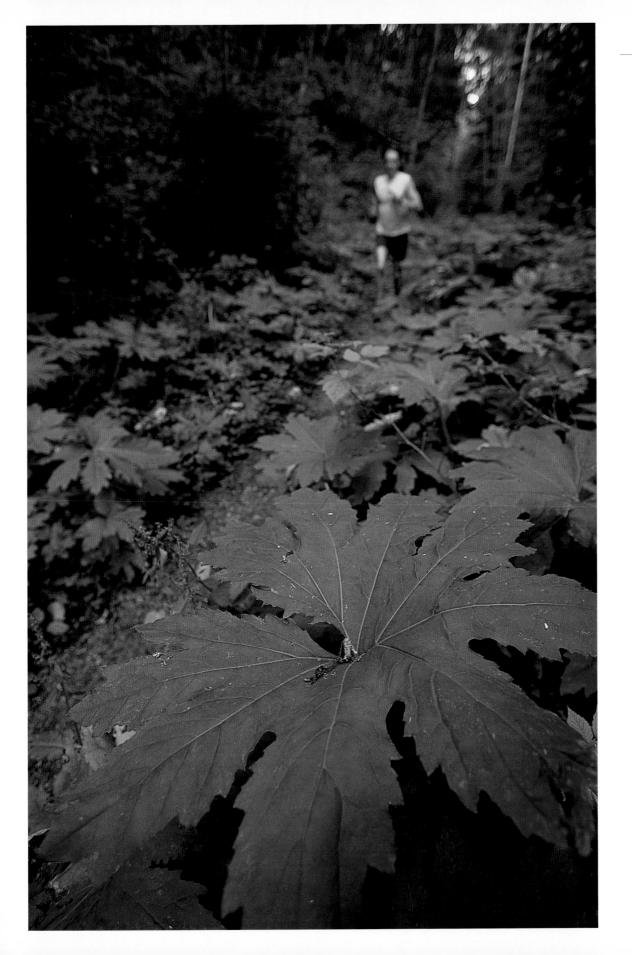

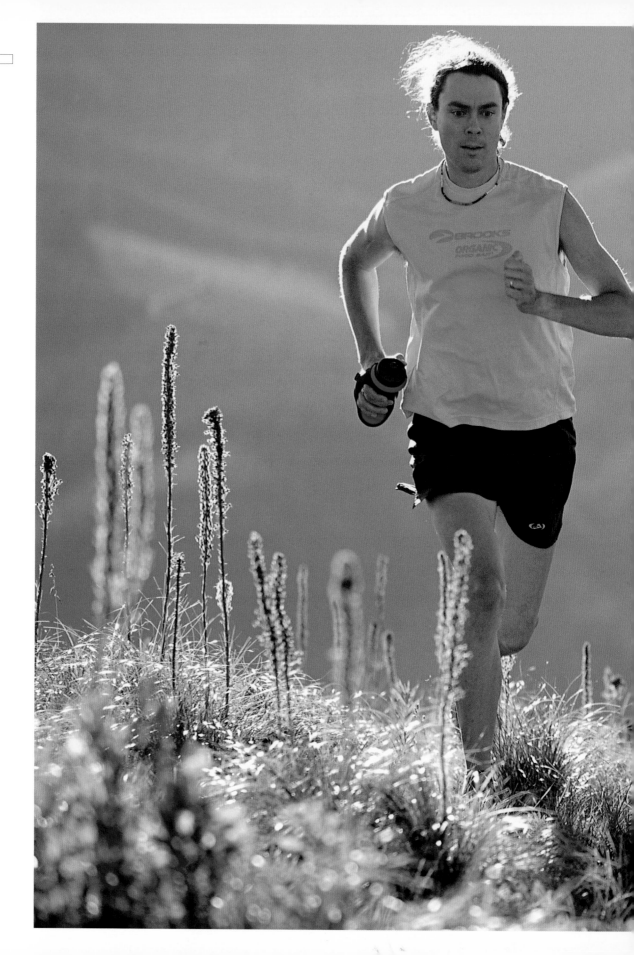

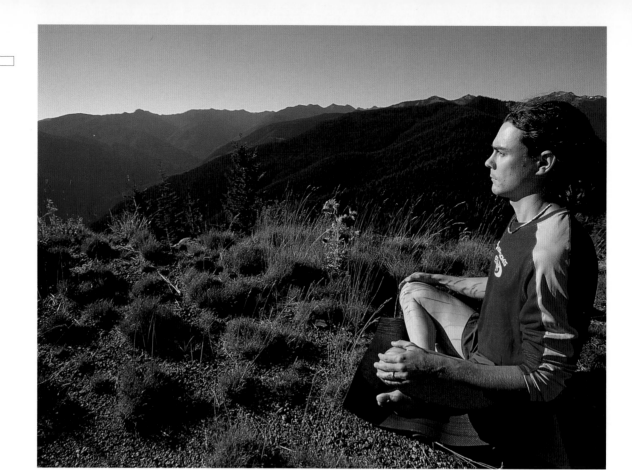

[PHOTOGRAPHER'S NOTES:

BEFORE FLYING TO SEATTLE, I called Scott Jurek and quizzed him about possible shooting locations. The ideal, I explained, would be a well-maintained stretch of trail with beautiful sweeping views, a spot that epitomizes where he trains but was still accessible. What I wanted to avoid was hiking several miles with thirty-plus pounds of camera gear on my back. After arriving, I quickly realized that Scott and I had a very different interpretation of the word *accessible*. To me, it means: step out of my car, grab my camera bag, walk a bit to a clearing in the trees that reveals a spectacular background, and begin shooting. Now, for a guy who runs a hundred miles at a time, *accessible* means something else.

When we pulled into the parking lot, I must admit I was a little confused. Scott had described this location as perfect for getting wide-open views of the Cascades relatively close to the car. This did not make a lot of sense to me, because the car park seemed to be at the lowest point in the mountain valley. I can usually look at a peak in the distance and make a pretty good guess at the amount of vertical gain between where I am standing and the summit. Here, I couldn't even spot the summit, but it was well over three thousand vertical feet to the horizon line that I *could* see. I assumed Scott knew of a clearing that was close, and I did not want to sound like a wimp, so I just kept quiet and started walking.

We began at what Scott would consider a "brisk walk." He knew we couldn't run because of the amount of gear I had to carry, but his walk was *fast* and the trail was steep. Scott continued to talk with no noticeable change in his breathing. I, on the other hand, quickly went into a deep breathing pattern, paying close attention to my footsteps and not really concentrating on what Scott was saying. Thankfully, he didn't ask me many questions, because it was almost impossible to complete a full sentence without gasping for air. We continued up, Scott totally unfazed by the climb, or by the effort he was expending. I frequently would break into a quick jog for a few seconds at a time just to catch up. At one point, I asked Scott

how much father to the clearing and he responded, "We are at least halfway there." We were easily thirty minutes into this torture-fest and 1,500 feet above the parking lot, and I was already in full suffering mode, when I realized that Scott usually *runs* this route. The guy is an animal.

Then I noticed that it was getting darker. When I could, I peaked out of the dense forest and saw that big clouds were forming to the south. I feared that, after all of our effort, we were about to be shut down by the weather. We finally arrived at the clearing. Giant, ominous dark clouds covered the sky completely, blocking the sun. There was no point in even trying to take pictures—we were too late. Scott, completely unaffected by the effort required to get into our current location, turned to me and said, "Well, I guess we will give it another try tomorrow."

BILL KOCH

09

Winter in Vermont is like a thief, stealing several weeks every spring and fall, giving cross-country skiers the ability to slide through forests and fields far longer than a single season. Taking advantage of every stolen day, Bill Koch is moving effortlessly on the edge of a farmer's field with a kick and glide on top of a few shrinking inches of snow. Soon the open view of a quaint farm will disappear with a turn into the trees. Bill's straight tracks will quickly evolve into a constantly changing path as he weaves past maples and over a stream filled with March runoff.

The hills and mountains of this part of New England are well suited for cross-country skiing. They aren't impossibly steep like many out west, and the deciduous trees mean the forest is fairly open once winter clears them of their leaves. But most of all, Bill says he enjoys this constantly changing terrain. "You learn how to carry a very efficient stride through ever-changing undulations each and every stride, not just a straight-ahead experience," he says, referring to skiing on modern, well-graded trails. Bill admits he has always lacked any type of super-human fitness, instead attributing his stamina and skill to training on these uneven trails, which made him a champion. "That's what really teaches the basic skiing skills, having that microtopography where nothing's graded, nothing's groomed—you just have to ski pure, natural terrain."

As he continues through the forest, however, it's apparent that strength doesn't hurt. Bill, despite pushing fifty, has the body of a World Cup skier half his age. Because of his skill on skis, Bill's strength isn't always obvious, but it's something he's had for decades. In 1976, he made U.S. Olympic history by winning the silver medal in the thirty-kilometer cross-country ski race in Innsbruck, Austria. In doing so, Bill became the first and, so far, only American to win an Olympic medal in the sport's history.

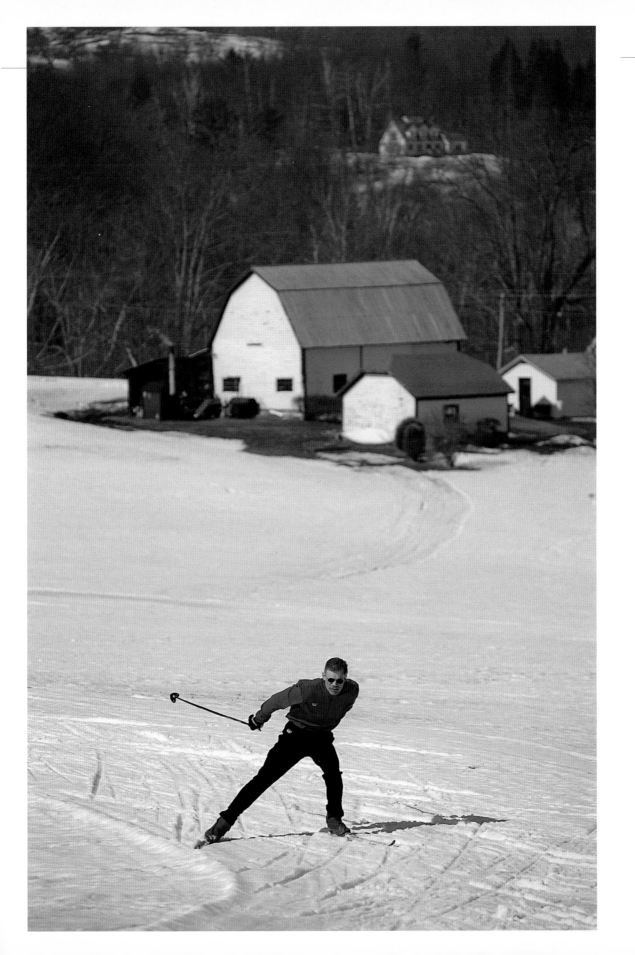

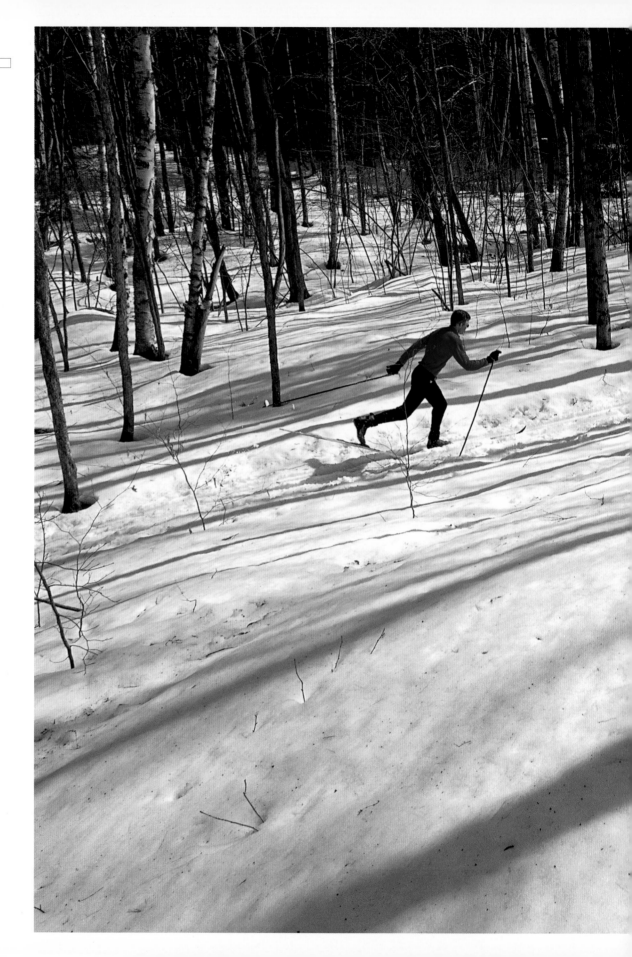

A few years later, he changed cross-country skiing forever when he ushered in a new style now known as skating. Using this new technique, he made history once again in 1982, becoming the only American ever to win the overall World Cup title.

These days, with two young children at home, Bill spends much of his time skiing the same terrain as he did in his youth. The school just down the road maintains some machine-groomed tracks, but Bill prefers once again to make his own that wind through the woods. "It's interesting how I've come full circle," he says, crossing a rolling untracked field between forests, "from making my own narrow little trails to school—the ungroomed, hand-cut little paths—through the racing, and now I'm back to the ungroomed trails through the woods."

Over the past two decades, Bill has crossed the country and even the ocean searching for the ideal place to glide on skis. He's lived in predictable ski spots such as the Pacific Northwest, as well as surprising locations like Hawaii. "The glide on sand is really good near the water, and you only need your skis, boots, poles, and shorts," he says, fondly recalling warm early-morning workouts.

Today, Bill cares more about exploring the roots of the sport, an experience he describes, speaking with the reverence of a yoga master, as very therapeutic. "Almost never do I think I shouldn't go skiing, even if I don't feel good," he explains. "Usually I go out when I feel something coming on, and nine times out of ten I feel better after skiing." The synchronized rhythm of arms and legs mimics the gait of apes, he notes. "I consider it to be sacred movement. It's just what your body wants," he says. For him, it clicked at age seven. "I can remember very clearly skiing around and around and around the lawn outside our house, and I can remember exactly where on the lawn, on this little dip, where it suddenly clicked and I got the diagonal stride," he says, referring to the classic cross-country technique.

Bill became obsessed with skiing as efficiently as possible. "I never took the bus," he says. "I'd ski the six miles to school every day." There were no groomed tracks; there weren't even trails to his school. "I cut a trail, just little turny, bumpy, dippy trails, climbing over fences, jumping over brooks— this is really where my roots are." He believes these early days on his own gave him the foundation he would use later in his competitive racing.

Today, Bill works with alpine ski areas to encourage more skiers, who usually ride the lifts, to give his beloved cross-country skiing a try. He spends countless hours poring over maps of the mountains, plotting trails that he will need to trim of branches and bushes once the snow falls.

While his young kids practice their skiing on the living room floor, Bill is in the basement gearing up for another morning on the trails. Surprisingly, he doesn't own a pile of top-of-the-line skis. His newest pair is probably a decade old. "When I was racing, I'd travel with a dozen pair of skis; I was absolutely obsessed with the latest gear," he says, grabbing skis worn to the core in several places. These days he's less concerned about having the fastest skis. "I just enjoy being outside," he says. Perhaps most surprising, though, is his casual attitude toward the most famous symbol of his racing days: his Olympic silver medal is nowhere to be seen. "I think it's in storage. It's just a hunk of metal," he explains. "The experience is in my head; it's in my body."

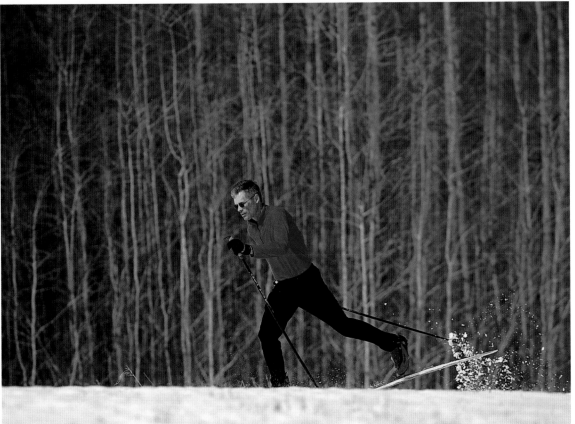

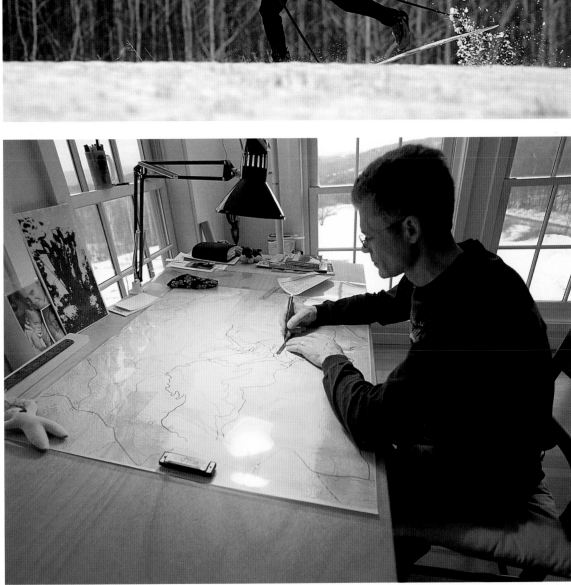

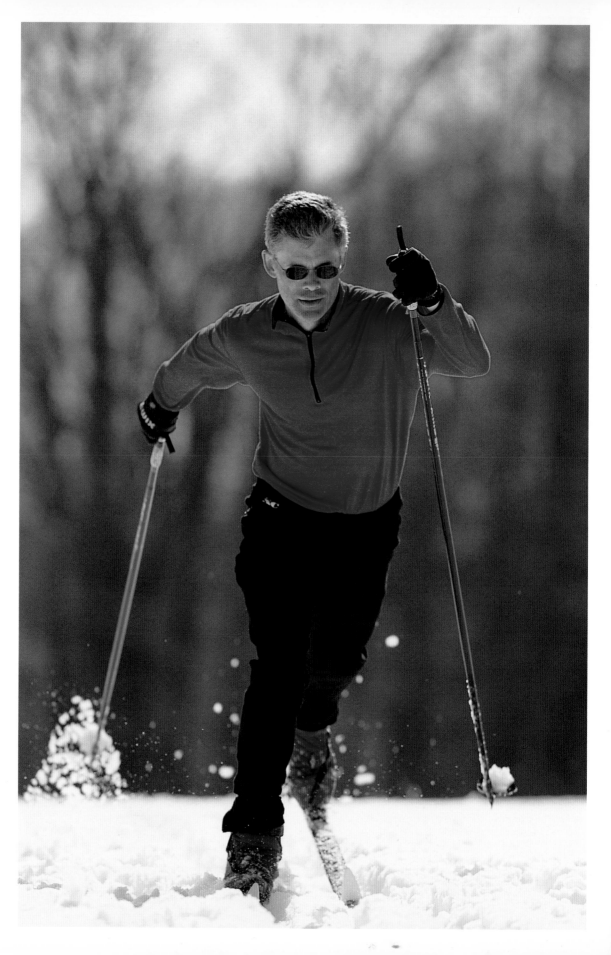

WE OWNED A NORDICTRACK when I was a kid, one of those archaic exercise machines with two pulleys, a jump rope–like cord, a waist-high stabilizing pad that you lean against for balance, and two ski-like things for your feet on the bottom, made of wood. Imagine that, wood. Anyway, the idea was to simulate cross-country skiing. You push your left leg forward and you pull your right arm back, then do the opposite. Sounds simple? It wasn't. It was hard as hell to stay on the thing for very long.

I had heard that Bill was a complete animal—hell, you hear that about most pro athletes—and when I showed up at his house and saw that he had a NordicTrack but had removed the stabilizing pad and jacked it up at least a foot in the front with bricks, I knew it was true. This guy was a stud.

By the time Jason and I finally arrived in Vermont to shoot with Bill, it was late in the season, and very little snow was on the ground. There were no icicles; there was no snow in the trees—not a winter wonderland by any stretch. This was one of the many challenges I have faced as a photographer: to make a less than ideal scenario look fantastic. Frequently I find myself in situations where I am asked to do a photo shoot for a spring advertisement in late fall, or to shoot a summer catalog in the winter in Tahoe (don't laugh—it happened). Here, we were concerned that we might not even find enough snow for Bill to actually ski on. But this is a guy who moved to Hawaii for a few years and missed skiing so much that he developed a technique for skate-skiing on sand. Bill assured me that regardless of the conditions he could ski.

So we searched out snow for two days. Bill brought us to every one of his beloved big snow patches within a one-hour radius of his home. Finally, we were on a section of privately owned farm property, shooting on a clean, nondescript patch of snow, when a big truck stopped on the road nearby. The driver got out and climbed the barbed-wire fence bordering the property. With a real sense of purpose, he marched over to us. I continued to shoot for the ninety seconds that it took for him to reach us, in fear that this would indeed be our last chance in this location. His greeting was, "You guys know this is private property and you are trespassing?" Now, I've observed that everyone has a different technique for handling the admission that, "Yes, I know I am blatantly trespassing." I've seen it all: apologizing profusely, playing dumb, arguing, flat-out lying. To our great fortune, Bill spoke up first. He had his own humble style of dealing with the situation: he told the truth. He admitted that, yes, he knew it was private land. Then he explained that he skis on this same ranch all the time and has never had problems. Bill instantly redirected the conversation to skiing, not trespassing. He talked, and we watched as the angry farmer settled down. When you love what you're doing as much as Bill, it's an easy sell. After a few minutes of listening intently, the farmer was actually smiling. He told us that his son loved to ski and was in the Bill Koch ski league. "This is Bill Koch," Jason finally said. The delighted farmer gave Bill a hearty handshake and was off to his car to get a shirt to be signed for his son. Needless to say, we were able to shoot on the property as long as we wanted.

JEFF LOWE

10

Frustration is setting in, and Jeff Lowe hasn't even begun to climb yet. Moving vertically comes naturally to this gifted ice climber. He is known for forging solo routes in the Himalayas and for first ascents on his favorite medium: the frozen waterfall. But right now, it's horizontal terrain that gives him trouble. Walking up the road to the Uncompaghre Gorge in Ouray, Colorado, he uses a cane; but on steeper terrain, Jeff transforms into a graceful alpinist.

Over the past several years, Jeff's body has been under attack from the symptoms of multiple sclerosis. Slowly, he's losing control over many of his muscles. He takes more time to prepare for a climb, and he takes longer breaks between climbs. But Jeff still finds time to ascend the frozen waterfalls, a sport he helped pioneer in the early 1970s. And when it comes time to climb ice, he still likes to visit the country's first ice climbing park, below the towering peaks of the San Juan Mountains.

Lowe stops on a bridge overlooking the canyon with its walls covered in ice. Years ago, a leak in a pipe along the canyon inadvertently created massive icicles that Jeff and a few other curious climbers ascended. Today, sophisticated sprinklers help build and sustain frozen sheets and pinnacles of varying shapes and difficulties. From the broad, even walls of ice in the "Schoolroom," where beginners can learn the basics, to dangling icicles dropping more than thirty feet from the overhanging rock, the gorge caters to just about every type of climber. During the park's early years, Jeff developed and tested the toughest climbs. He returns to Ouray because he says there's nowhere else a climber can find as many challenging routes in a place that is both accessible and reliable. The ice is always growing in Ouray, and the locals make sure there are always new ways to test the limits of the sport.

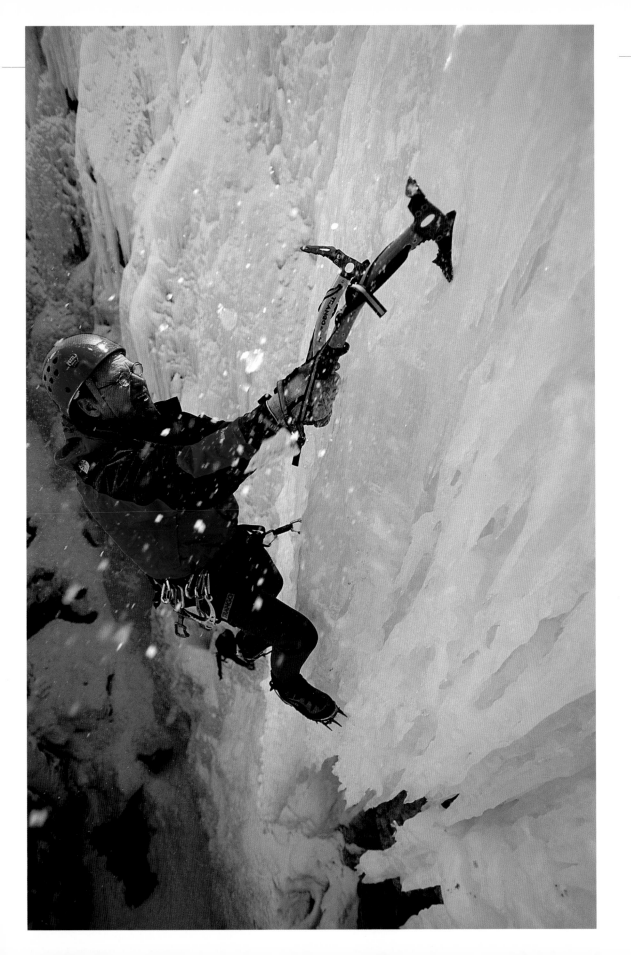

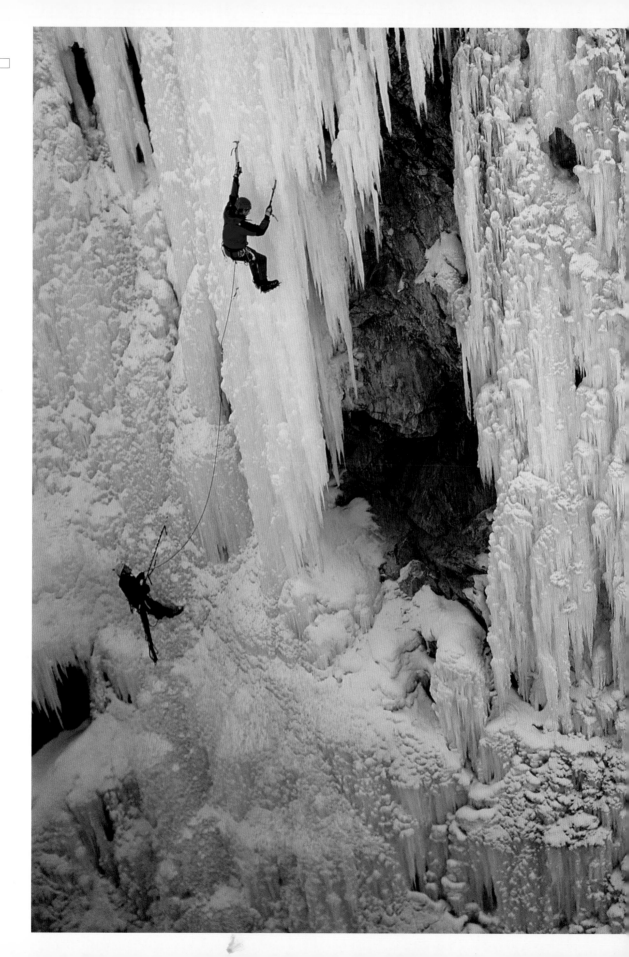

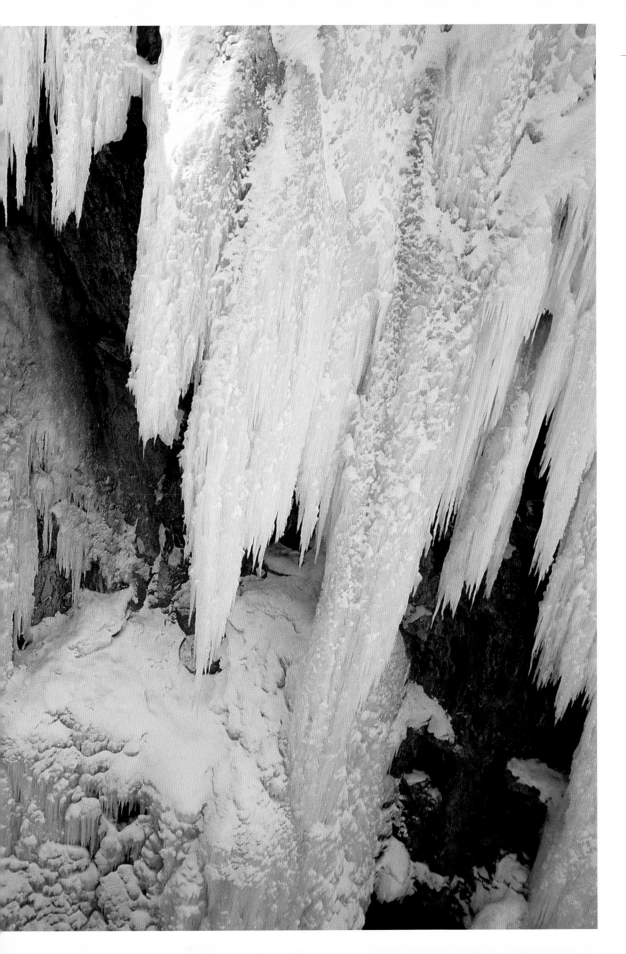

Climbing here is done backward. Climbers secure their rope to anchors at the top of a route and then rappel into the canyon. They then pull down the rope and start from the base. Ice climbing in Ouray is a sport where the challenge is in the delicate physical motion.

On his climb, Jeff wastes no energy. With short, deliberate kicks, the points of his crampons penetrate the ice. Relying more on experience now than pure strength, he carefully scans the chandeliers of frozen water, then swings his tool, sinking it with a satisfying thud.

Watching Jeff climb, you would never guess that he struggles to walk. On the ice he moves with precision, with the grace of a veteran who has been making these same moves for most of his adult life. He looks as good on the vertical as anybody in the park. But Jeff insists the hard part of his disease is knowing that his body can no longer accomplish what he pictures in his head. "I get to a place where it feels good," he laments, "but I know what I *should* be capable of doing."

Kick. Scan. Swing. Jeff settles into a groove and moves slowly up the face, just as he has all over the world for more than three decades. Few can match his climbing accomplishments. Exploring the mountains around his northern Utah home as a child, Jeff completed climbs that would scare some of the most dedicated mountaineers. As he grew, so too did his expertise. He started establishing new routes throughout the Rockies and eventually took his alpine skills to Europe and the high peaks of Asia, where he established several new routes, always in a bold

alpine style, relying primarily on himself rather than a team of porters carrying his gear. Jeff is best known in the climbing world, however, for his work in developing modern ice climbing. "Waterfall ice climbing was sort of in its early stages," he says, recalling some of his first climbs in the early 1970s. Before the late 1960s, vertical ice was largely off-limits because of the limitations of equipment. Then climber and gear maker Yvon Chouinard created curved-pick ice axes. "Before that, they were all straight," Jeff says, "and if you tried to pull on one, it would just pop out on you."

That innovation spawned a whole new sport, and Jeff was poised to claim it. He and his brother started on the vertical ice near their home in northern Utah and explored Colorado with another climbing partner, Mike Weis, before hearing the buzz about a frozen waterfall near Ouray. Their first ascent of Bridal Veil Falls, just over the mountains from Ouray, made history, in part because it involved adapting techniques and tools for a new medium. "We didn't know if it would just topple over on us," Jeff recalls. "We didn't have any experience on multipitch vertical ice." The ascent ushered in a new era of climbing. "We were adapting techniques to this new waterfall medium; it was pioneering."

Today, as he continues to deal with his disease, Jeff pauses when it comes to discussing the future. "I'm not sure if I want to continue trying to climb," he says with a blank stare. He believes he's past the hard part of coming to grips with his new life, and, with guarded optimism, he says the mountains will continue to call to him. "I'll probably try to climb some," he says, deep in thought. "I'm just trying to figure that out."

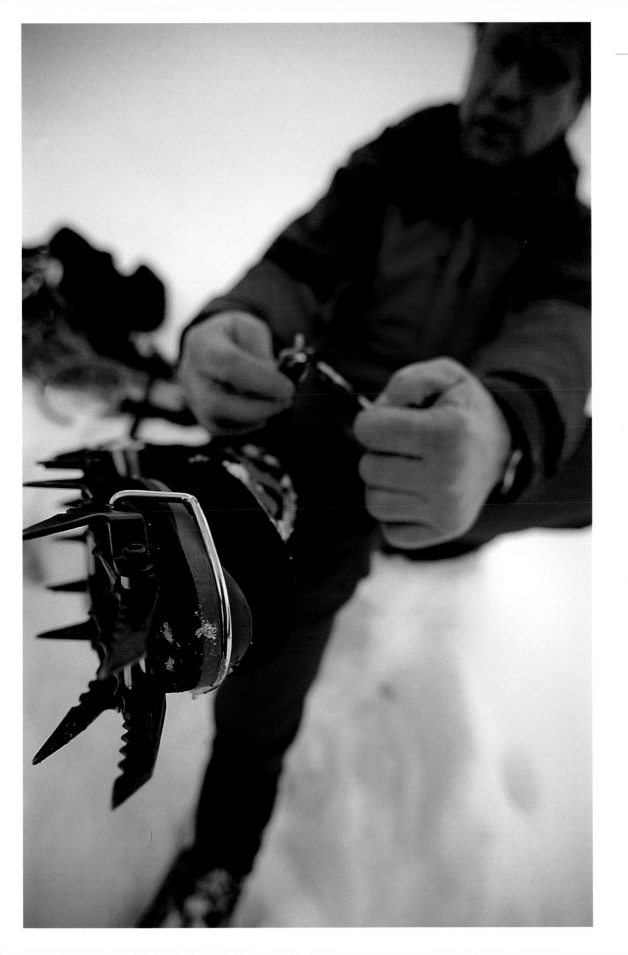

[PHOTOGRAPHER'S NOTES:

A VERTICAL ENVIRONMENT introduces a unique set of challenges—both for Jeff Lowe and for photographers like me. When shooting, one's feet are dangling in space, not planted firmly on the ground. There are ropes, climbing hardware, heights, and exposure to deal with. I've probably spent close to a year of my life hanging on ropes shooting climbers, and I've gathered a few techniques to make the experience less painful and more efficient.

A good climbing harness is key. All of my body weight, plus the weight of my camera gear, climbing equipment, water, and food, rest on my harness. There is no way to make being in a harness for days at a time feel good—it just plain hurts. That said, I use a Black Diamond big-wall harness. It is as comfortable as possible, it's well padded, and it has a lot of reinforced gear loops. Yes, it's on the expensive side, but three hours into a two-day trip, the extra thirty bucks will be worth it.

Once I'm off the ground, my equipment is always attached to either my harness, the rope above me, or the wall. It makes no difference whether I am working ten or a thousand feet up; any equipment and film I drop either will be destroyed on impact or will never be seen again. Often I am hanging directly over the climber that I am shooting, so if I drop a four-pound lens on them from thirty feet up, it will get ugly. I get in the habit of adding tie-offs to all my equipment, and I use them whenever there's even a possibility of dropping anything.

Camera bag selection is key. I find that the Lowepro Orion AW is the ideal big-wall bag. The over-the-shoulder harness system combined with a waist strap lets me secure the bag very close to my body or simply hang the bag over a shoulder when I need more range of motion at my waist. To prevent losing my camera, I don't use the stock strap. Instead, I replace it with thin, full-strength climbing webbing, tied to the camera body with water knots. I find the webbing to be very easy to handle, soft on my neck and strong enough to support the weight of the camera and a long lens. Also, in an emergency, I can use my camera strap as a piece of climbing equipment. (This has actually happened!)

If I'm shooting from a fixed rope, I use my top ascender as the power point for hanging equipment. As soon as I get to a location from which I'm going to shoot, I take my camera bag off over my shoulder and clip it into my top ascender, keeping it clipped to my waist until it's secure. I then unzip the bag and clip the camera strap into the same point. This places the bag at waist level, where it acts like a net on which I can safely change lenses and film. The high power point also acts as a support for the camera's weight and keeps me in a very stable position.

Finally, less is more. This is truly the case when shooting rock climbing or ice climbing, because I have to haul every ounce up the wall, potentially thousands of feet. I almost never carry more than a 16-35mm lens, a 70-200mm lens, one camera body, a light meter, and film.

But the most important thing I can say is, be careful! I have taken the time to get comfortable with the rope systems, my gear, and the vertical environment. Now I concentrate on what I love most: taking photos.

11

SHANE McCONKEY

MY FAVORITE
PLACE

118

Page

ATHLETE

Shane McConkey

SITE

Twin Falls, ID

SPORT

BASE jumping

LATITUDE / LONGITUDE

42°36'N / 114°27'W

The Snake River flows 486 feet below the bridge from which Shane McConkey intends to jump. Cars speeding toward or away from nearby Twin Falls whoosh by as he swings his legs over the metal rail and stands on the thin ledge with his back to the water. Shane smiles, and the next thing we see is this: He is free-falling. *One, one thousand. Two, one thousand.* In seconds, his parachute pops open with a crack that echoes through the deep canyon. So does the yell that Shane uncorks the moment he touches down on a gravel bar alongside the river. "A few seconds of BASE jumping," he says, "is like a great day of heli-skiing."

Jumping off bridges was the natural next step for a skier who spent the past ten years carving up some of the steepest slopes in the world. Often, he launched his descent from a hovering helicopter. So why not leap off buildings, cliffs, and other structures?

The sport has a bit of a rebellious reputation. "BASE jumping isn't illegal," Shane explains, trying to dispel a misconception he commonly hears.

"Trespassing is illegal." Most of the time if there's something high enough to jump off, it belongs to somebody. And more often than not, that somebody doesn't want anybody trespassing just so they can take the fast way down. Though he does concede that it is technically illegal to jump in some places (national parks, for example), Shane wants to break the stereotype that BASE jumpers are lawbreakers. "We're not trying to do anything bad," he says. "We're just trying to borrow some altitude." Watching him leap the handrail once again, this time performing a double backflip, Shane sounds sarcastic and sincere at the same time.

The 1,500-foot-long Perrine Bridge is a premier destination for BASE (an acronym for

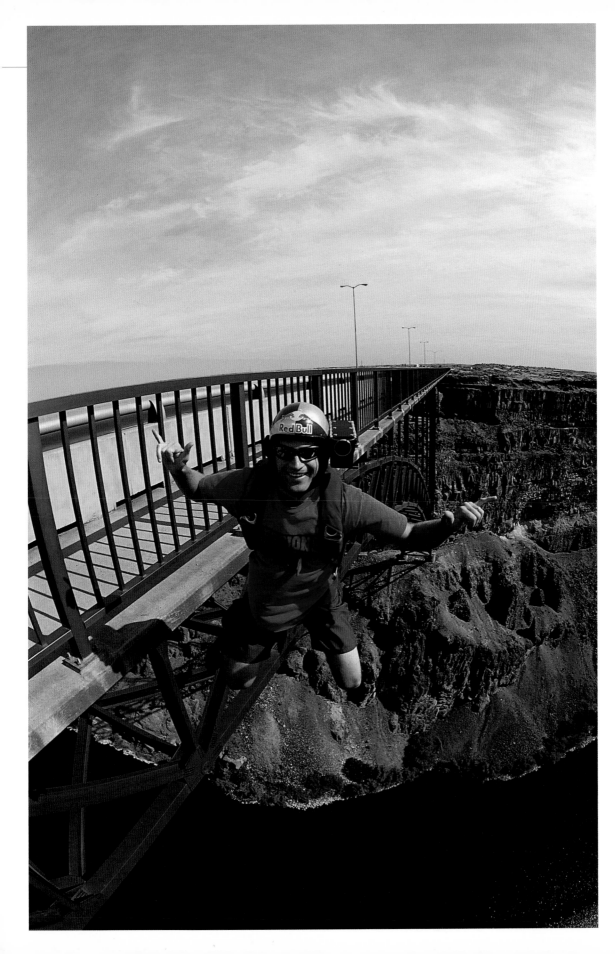

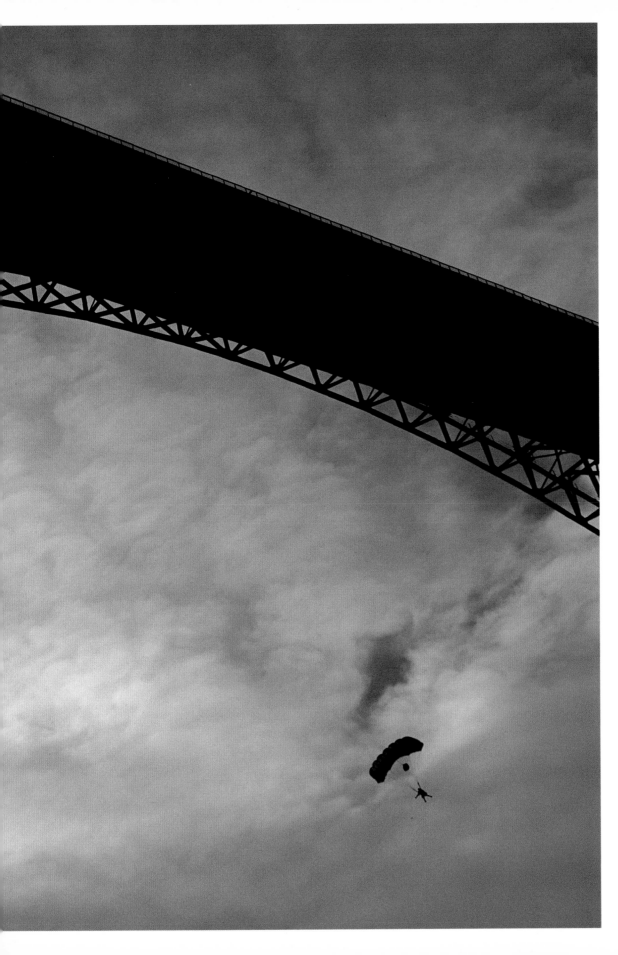

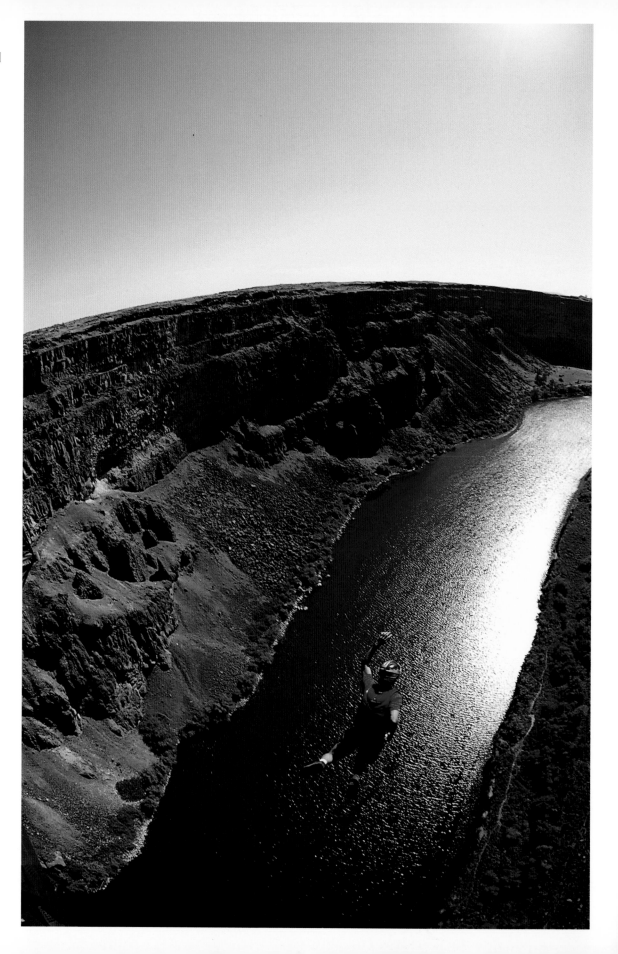

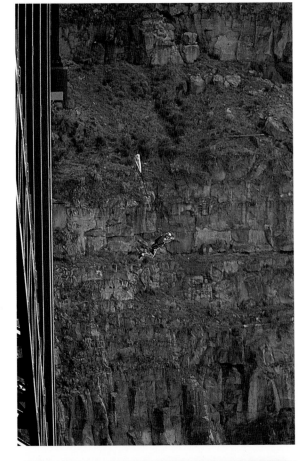
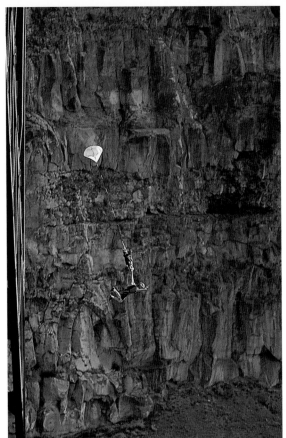

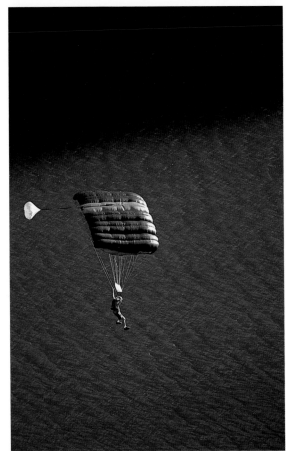

Building-Antenna-Span-Earth) jumpers because it is one of the highest rim-to-rim bridges in the United States. And the people here, in south-central Idaho not only permit jumping, but promote it as a major attraction for the area. Unlike West Virginia's New River Gorge, where "Bridge Day" attracts a mob of jumpers once a year, the Perrine serves a steady trickle of BASE enthusiasts year-round. The visitor's center sports a WATCH FOR BASE JUMPERS sign. Truck drivers and soccer moms buzz past the men and women lined up on the side of the four-lane highway with-out so much as a glance. "The police wave at you when they drive by," Shane says. The professional adventure athlete comes here several times a year both to enjoy himself without risk of trespassing and to teach friends and other first-timers.

"It's a span, so it's really safe," Shane says. Unlike jumping from a cliff, a building, or an antenna, with a bridge there's little chance you're going to hit the structure, something that can happen during free-fall or when the chute pops open. There's also the option of landing in the water, which of course is more forgiving than land if any complications arise. "It's perfect for beginners," says Shane, though he cautions with a favorite joke: "If at first you don't succeed, BASE jumping is probably not your sport." The safety is not only good for beginners; for Shane it allows that extra margin to explore new tricks. "It's great because you can make lap after lap after lap, trying anything you want."

Sitting on the grass next to a small parking lot adjacent to the visitor's center, Shane packs his chute for his third jump. Though it looks like a skydiving parachute, a BASE jumper's chute opens faster, and there's no reserve chute. Instead of pulling a rip cord, the free-falling jumper throws into the air a small pilot chute that has been wrapped into a ball and is either held in the hand or attached to the harness. It inflates, triggering the main chute. The entire process, from throw to main-chute deployment, happens in just a second or two. The delay can be adjusted depending on personal preference. The lower the jump, or the shorter the desired free fall, the quicker inflates the chute. The downside is a more jarring pop when it does open. The precious seconds of free fall constitute the best part, according to Shane. "BASE jumping is really calm," he says. "The air is very still. It's subterminal air." With only three or four seconds of free fall, BASE jumpers leaping from the Perrine Bridge don't reach the noisy 130 miles per hour terminal velocity obtained by skydivers. Even better, the free fall feels much faster than it does in skydiving. "In BASE jumping, the ground is moving as soon as you step off."

Their chutes packed, Shane and a friend walk back out to the middle of the Perrine. On the way, they make a wager, a dollar going to the man who executes a triple backflip with the most style. *Three-two-one . . .*

PHOTOGRAPHER'S NOTES:

MY GIRLFRIEND, KIM, AND I were getting really serious around the time this shoot with Shane came up, and she'd never traveled with me on a project. I figured this would be a perfect first time; when I asked Kim to accompany me, she was psyched.

I spoke to Shane the next day, and the conversation was pretty standard right up until the end, when Shane added, "Oh yeah, one more thing. Don't forget to bring some swim trunks and a giant set of balls."

"Excuse me?" I said. He answered, "If you want to shoot me BASE jumping, you have to jump—that's the deal." Shane chuckled and promptly hung up.

While I'm not afraid of heights by any means, jumping off a 500-foot bridge with a single parachute was way out of my comfort zone. Then there was the Kim factor—this would be my first shoot with her, and I wanted to look like I had everything under control.

I devised a plan. I would tell Kim about Shane's deal, but only after explaining how dangerous BASE jumping actually is. The standard prerequisite for BASE jumping is to complete a hundred jumps out of an airplane, and I had never skydived. I imagined that after telling her all this, she would beg me not to do it. I told her what Shane said, and her eyes widened at all the right places, but when I finished, she looked at me with all the excitement of a kid on Christmas morning and asked, "Can I jump, too?"

Now I was really screwed.

We shot for two days while Shane and his buddies jumped dozens of times. At the end of the second day we were packing the car, and I was thinking, we're safe, we won't have to jump. Then, like a bad dream, Shane asked, "Are you guys ready?" Before I could kick her in the shins, Kim piped up, "Hell, yes!" In my head, I was arguing with myself about how deranged this was, until bravado overtook reason and I consented with all the fake confidence I could manage.

Shane gave us a five-minute tutorial, but I wasn't really paying attention. A few minutes later, Kim and I were standing outside the railing of the bridge in the howling wind. I was insanely nervous and coming up with last-minute reasons why I couldn't jump, when Kim and Shane pulled the plug. "Just jump," they said. So I gave it a three count, let out an crazed primal yell, and chucked myself off the bridge.

I threw my pilot chute. It opened, I grabbed the brakes and the next thing I knew I was steering myself toward the shallow edge of the river. Miraculously, I landed in the water unharmed. I looked up as I heard the thundering crack of Kim's parachute opening, and watched as she soared toward the ground. Shane drifted down after her. At this point I was just glad to be alive. Kim and Shane, on the other hand, met in the water with the kind of crushing hug for which football players are famous, and I am thinking to myself, who is this woman, and where is my girlfriend?

As of the printing of this book, Kim and I are still together, and thankfully she hasn't turned into an avid BASE jumper. Maybe that's a prescription for relationship success: go jump off a bridge together, and if you survive, it was meant to be.

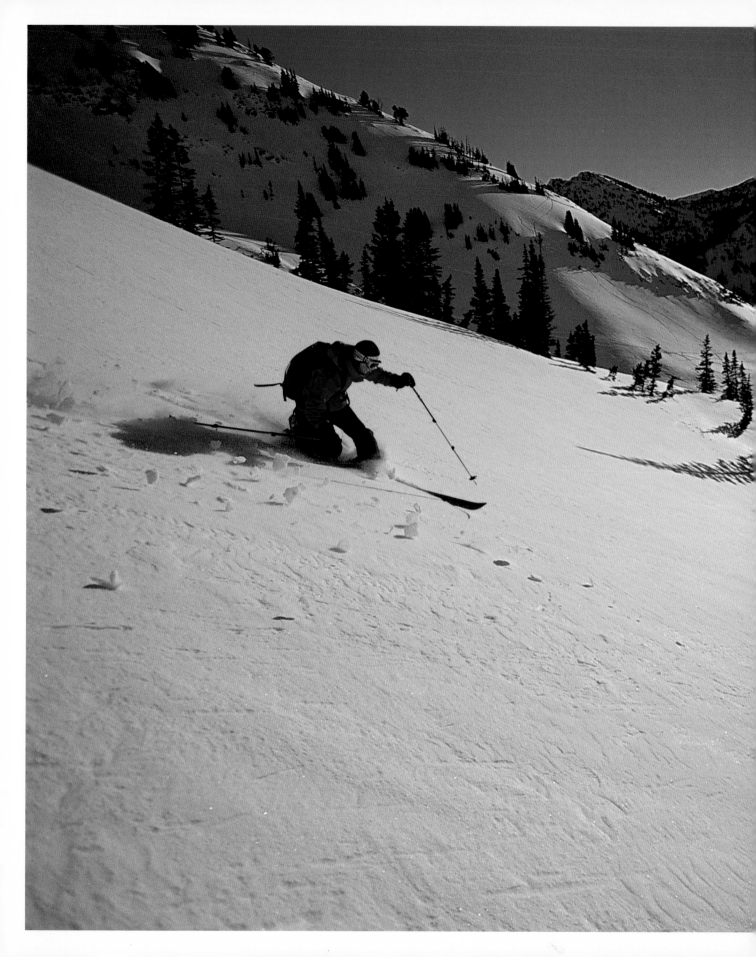

12

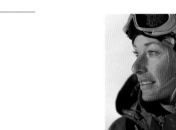

"There's a culture that goes with these storms," says professional telemark skier Kasha Rigby as she prepares for a morning tour through Utah's Wasatch Range. "We get into a storm cycle where it snows every night, the [Big and Little Cottonwood] canyons close, there's a lot of energy, and everybody gets so excited." As Kasha slips into her square-toed telemark boots, the excitement is apparent on her face. The almost daily ritual of snow, road closures, and deep-powder skiing is all part of what people love about the region. "You meet your friends for coffee, constantly calling the snow report, just waiting for the roads to open."

At the base of the Little Cottonwood Canyon is a typical suburban landscape, complete with base-ball fields and culs-de-sac. Just fifteen minutes up the road lie high mountain ridges, open glades, and some of the best skiing anywhere, according to Kasha. "There's no better snow on the planet," she says.

This morning Kasha is parked at a trailhead in Little Cottonwood Canyon. Directly facing her is a broad, steep mountain ridge extending east to a rising and narrowing canyon and west to the vast open sky of the Great Salt Lake basin. Behind her extend alpine valleys lined with patches of cotton-wood trees and rock faces that will serve as the backdrop for this morning's long, trailing arcs through the powder.

As a light snow dusts the surroundings, Kasha stands at the back of her car and attaches the "skins" that will give her the traction to climb steep slopes without slipping backward. There's a well-packed track in the snow leading away from the parking lot into the open valley above. Already, with the road open for just a short time, others are skinning their way to the mountaintops in search of the world-famous

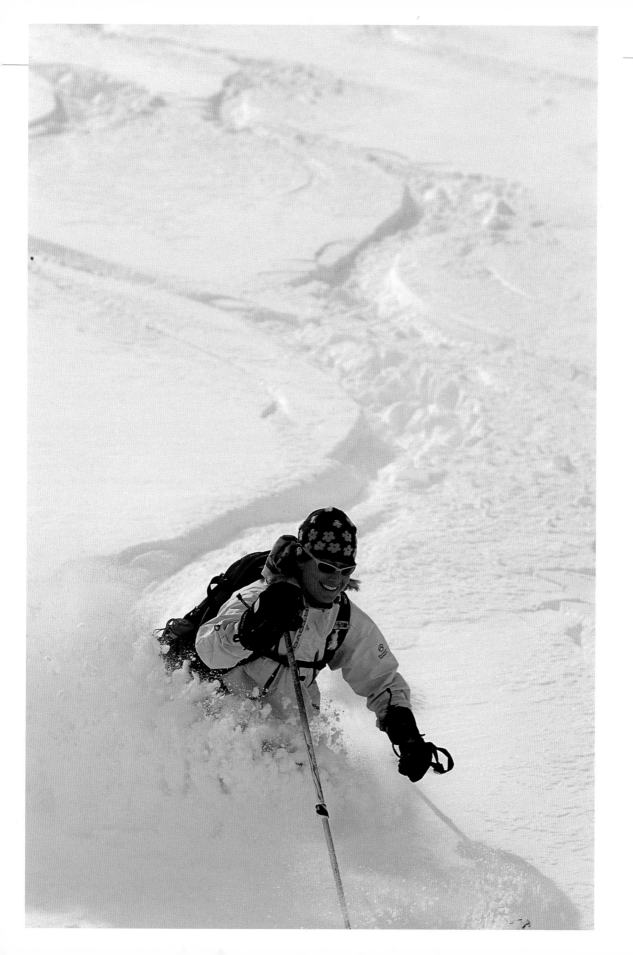

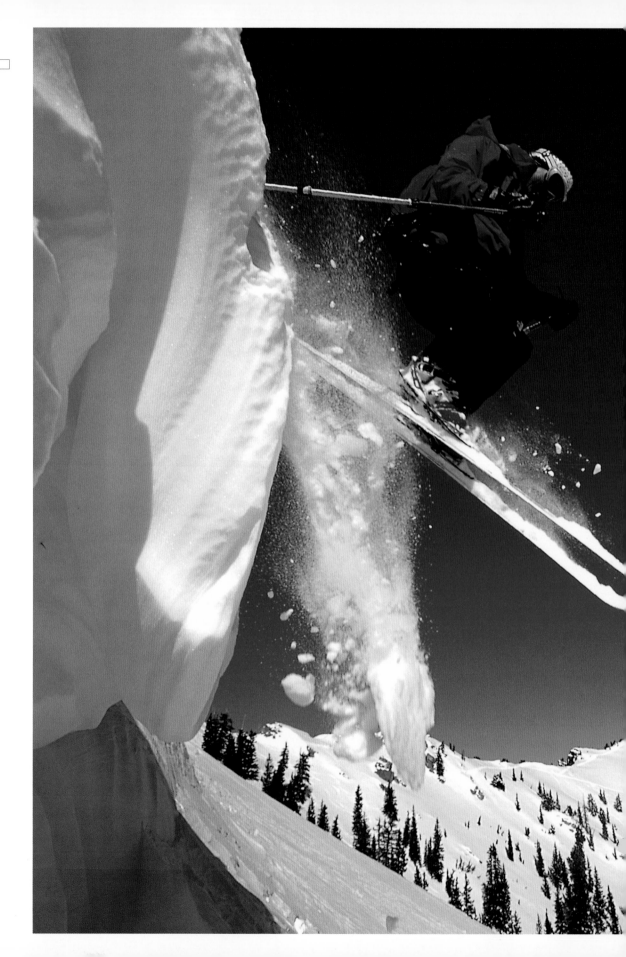

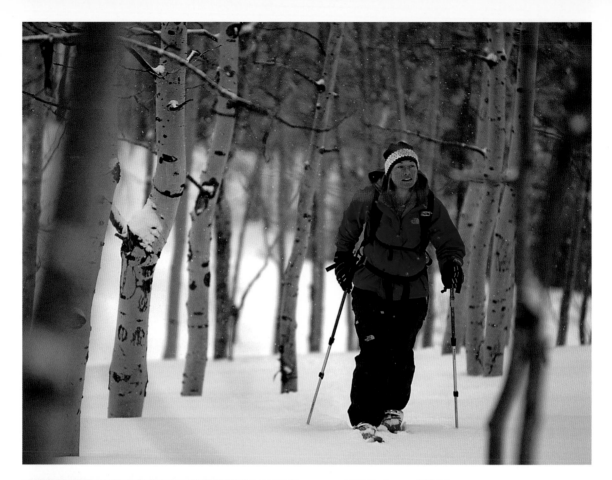

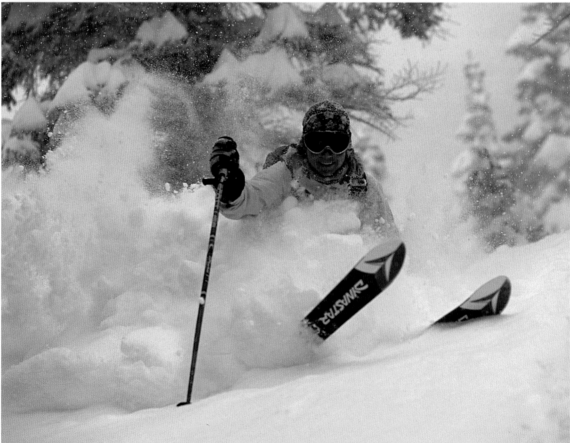

Utah powder. Kasha says there aren't too many places she's been where you can be ski touring such a rugged mountain range so close to a city. "I've been smack downtown in Salt Lake and [the mountain is] barely thirty minutes away; sometimes I go up at four in the afternoon and can get a lot of good skiing after just an hour of skinning." Fully prepped, Kasha heads off toward the thigh-deep snow. The crunch of skis and a creaky telemark boot orchestrate her morning tour.

Kasha, now in her thirties, grew up in a ski town in Vermont, but as a youngster she didn't dream of skiing. "I wanted to be Dorothy Hamill," she says. Kasha trained as a figure skater and says she had the strength, but the finesse eluded her. So Kasha put her strength to work and joined the local alpine team. Then, during a training session with the Nordic team, she discovered that she skied better with her heels free, and she made the switch to telemark that would take her around the world in search of an endless winter.

Telemark gets its name from the region in southern Norway where the technique was invented more than a hundred years ago. Dwarfed for decades by the alpine skiing boom, today telemarking is back in vogue, with magazine layouts and skiers in the ski movies showcasing the elegant rhythm of its slow, carving turn.

After high school, Kasha landed in Crested Butte, Colorado, a telemark hotspot, and a few years later turned heads when she entered the U.S. Extreme Skiing Championships, an alpine event, as a telemark skier. And while placing fourth in a pack of top female skiers may not have caught anyone's attention, because Kasha did it on telemark skis she landed on the cover of outdoor and ski magazines that rarely even mention the old-fashioned Norwegian technique.

Kasha no longer enters competitions but, as a ski mountaineer, she embarks on back-to-back expeditions in places such as the Alps or Pakistan's Karakorum Range. And when it's time to take a break from the airports, travel visas, piles of bags, bad water, and long truck rides that make up a typical expedition, Kasha revels in the ability to park her car at a Wasatch trailhead, put on her skins, and play. "I like the familiarity because I have very little of it in my normal life," she says. "I know my next turn a lot of the time; I like the idea of knowing where I'm going."

At the nine-thousand-foot mark on her morning tour, Kasha climbs a short, steep section near the top of a windy, tree-lined ridge. She strips off the skins, tucks them in her jacket, and moves to the edge of the trail. After a quick glimpse at the trees below, she lowers a knee and disappears in a trail of billowing powder.

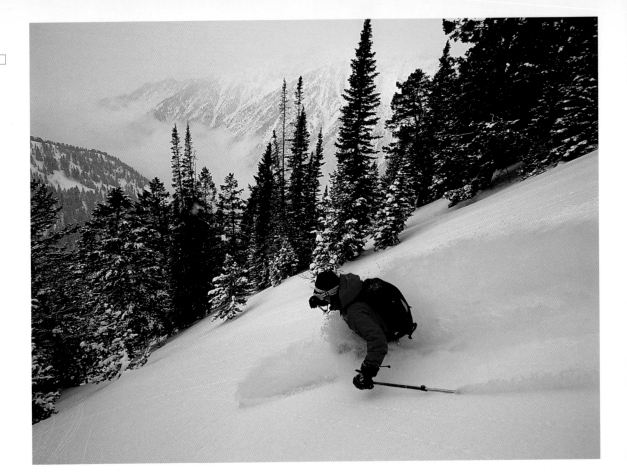

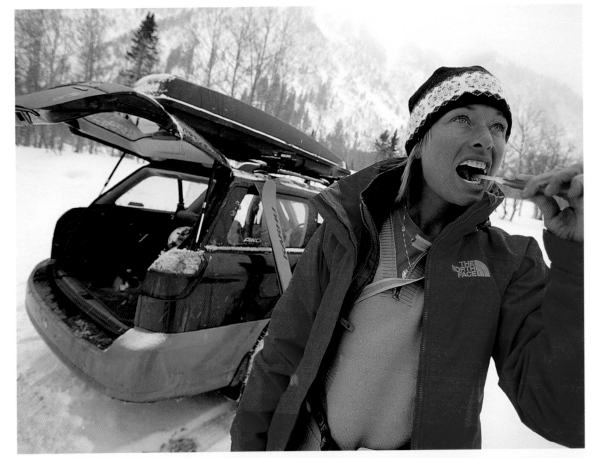

[PHOTOGRAPHER'S
NOTES:

────────────────

SOMETIMES GREAT PHOTOS FALL INTO MY LAP, and other times I pay dearly for them. Photographing Kasha has never been easy. The first time I ever shot with Kasha was for Polartec. The ad read, "Imagine a world without Polartec," so I had to photograph Kasha nude, covered only by her skis. Needless to say, it was an interesting way to break the ice, but it marked the beginning of a great friendship.

When I traveled to Utah to shoot with Kasha for this book, Mother Nature did not cooperate. Shooting any snow sport is extremely conditions-dependent. You need several factors to all come together at the same time: a foot or more of fresh snow left overnight, a beautiful sunny morning following the storm, cold temperatures, and a great athlete. The athlete part we had covered; the rest proved to be an almost insurmountable challenge. On my first planned trip, we got shut down. It had not snowed in days and the sky was overcast. Overcast light is the ski photographer's worst nightmare: because snow is white, it reflects the sky, and when the sky is gray the entire image is almost unreadable on film. We tried everything; I even prayed for the sun to come out. I flew home from Salt Lake City with only a few rolls of Kasha brushing her teeth near her car.

Both Kasha and I watched the weather for weeks afterward. We needed the weather to cooperate and our schedules to align. This is virtually impossible for two people who both travel over two hundred days a year. Nearly the entire season passed, and an opportunity never presented itself. We both knew that if we didn't shoot we wouldn't have photos for the book, so I flew back to Utah knowing that it had not snowed in over a week, but it was cold and we had a one-day window for sun. I knew that Kasha could make even the worst snow look fun and easy. I arrived around midnight at Kasha's home, and we decided we would leave the next morning at 4:30 A.M. so that we would have time to skin up to the ridge in the dark and be in position for the sunrise.

This is one of those times when photos can be deceiving. The snow was actually ice—I would have been better off ascending with crampons rather than skis and skins. Operating on four hours of sleep was slow, cold, and painful, not to mention tiring. We made it to the top of the ridge about half an hour before sunrise, and while we were waiting, I caught the edge of my ski on the frozen snow and fell, sliding on my back for more than fifty feet—just a silly, clumsy mistake. The worst part was the camera smacking me square in the face and breaking my nose. I climbed back up the ridge with blood dripping all over me while Kasha laughed so hard she almost fell down, too. The sun finally came up and we shot some great pictures, but, I must admit, the photos in this chapter were hard-won and my nose won't ever look the same.

THE ROSS FAMILY

13

The mountains of central Pennsylvania

undulate like waves behind a passing boat. The long, slender ridges of the Appalachian Range, a chain of mountains that long ago lost their dramatic peaks and massive cliff walls, form the backbone of the eastern United States. Their ridges and valleys are the template for a trail that connects the deep South with the far North. The Appalachian Trail, or "AT," as it is commonly called, evolved from the vision of Benton MacKaye, who wanted to develop a continuous footpath as a retreat from the rigors of daily life. In the 1920s and '30s, he and volunteers carved out the trail, which stretches 2,200 miles through fourteen states.

Since then, millions of people have hiked part or all of the Appalachian Trail. Some spend the afternoon exploring a short section; others spend years covering every mile. The AT has a culture all its own. Welcoming hostels are sprinkled along the trail. Volunteers maintain it, which for many becomes a lasting part of their lives.

An avid hiker who completed the AT while in her twenties, Cindy Ross lived near the trail in the early 1980s and occasionally offered trekkers a home-cooked meal. Todd Gladfelter was one of them. Years later, they met again, married, and built a life together, grounded in their passion for long-distance hiking. Cindy wrote a book, the now-classic *A Woman's Journey,* about her hiking experience. She and Todd raised a family and worked as caretakers in one of the many hostels that accommodate "thru hikers"—hikers who attempt long stretches of the trail at a time. "If you couldn't be on the trail, you had hikers coming in," says Todd, who first completed the AT at age nineteen. "It still felt like part of your life."

Cindy grew up along the trail. "When I was fifteen I saw my first thru hiker," she remembers. "We asked him where he was going, and he said 'Maine.' I just remember thinking, 'Wow, what an adventure.'"

The Appalachian Trail is an amazing accomplishment—organized yet challenging, offering a mixture of intuitive route-finding and true wilderness, miles from help. Along its length, there are painted rectangles called "blazes" to mark the trail. White blazes on trees, rocks, or posts label the main trail. Two white blazes tell hikers to watch for obscure turns or route changes. Blue blazes show the way to water, shelter, or side trails. And at the numerous road crossings stand signs pointing to Maine and Georgia, the trail's northern and southern endpoints.

In their more than twenty-years of marriage, Cindy and Todd have completed other thru trails, including the Pacific Crest Trail, which runs through Washington, Oregon, and California, and the Continental Divide Trail, which meanders across the crest of the Rockies. They tackled the latter with their two children, then toddlers, as well as a llama, in tow. The experience inspired Cindy's second book, *Scraping Heaven,* and a series of workshops in which she and Todd coach other couples on how to hike as a family. "It's just a little more work, but it's a hundred times more fun out there with them," Cindy says.

The family spends much of the year on the trail, earning the children the distinction of being "the kids who get to miss school." Sierra, their teenage daughter, says: "Some of the kids brag about going on a hike for two days. We go hiking for a month,"

in places throughout the United States and abroad. "Legally, they're allowed five days," Todd says, explaining the family's effort to find a balance between time missed in the classroom and time gained in the forests. "We burned those up the first five days of school this year." Central Pennsylvania has plenty to offer, too, from the white blazes of the AT to open fields rustling with insects. "Pennsylvania has more miles of marked trails than any other state in the country," Cindy points out. Not every trip is an expedition for the family. A favorite outing close to their home, north of Hamburg, is the Hawk Mountain Sanctuary, where ridges form a slight jog in the trail and serve as a gathering place for thousands of raptors every year. Oaks, maples, birch, and the occasional swath of pine and hemlock stretch from valley floor to rocky peak. In the fall, leaves blanket the trail in stunning color.

The sounds of birds and rustling foliage fill the air one fall afternoon as Cindy, Todd, their son, Bryce, and Sierra follow blue blazes to a side trail off the AT. Bryce races ahead to a rock outcrop he knows is just around the corner. This is a place they've been before many times. From the rocks, the expanse of the valley below the sanctuary opens before them. "The self-reliance we learned on the trail has encouraged us to live a simpler, happier life," Cindy says. "We may not be rich, but that's not our goal. We're free to do what we love in life; that is what the trail has given us."

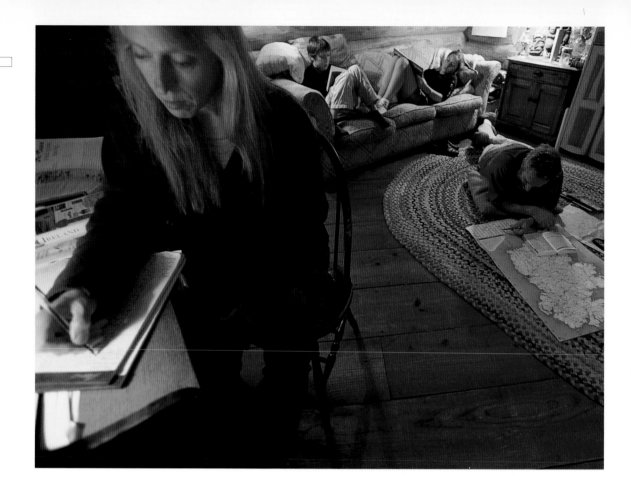

[PHOTOGRAPHER'S
NOTES:

SPENDING TIME WITH THE ROSS FAMILY was an amazing study in differing lifestyles. We scheduled the shoot at a very busy time for Jason and me, and when he and I met up at LaGuardia airport in New York we were both on our cell phones and in desperate need of an Internet connection. We logged several hours of drive time to the Rosses' home in Pennsylvania, and the work chaos kept up almost the entire way. Twenty minutes from our destination, we turned off the interstate and lost cellular service. Suddenly, we snapped out of it—we'd just spent three hours in the same car and had hardly spoken to each other. This is not unusual; it's the reality of managing our freelance businesses.

We quickly discovered, though, that we had arrived at a place that's about as far removed from the high-tech, fast-paced world as you can get. The Ross family has chosen a simple, meaningful life—they live in a log cabin that the family built together on a dirt road out in the woods, and none of them has a cell phone. Sure, they share some qualities of other modern families: both Todd and Cindy work every day, there's a computer in the house, the kids go to public school, and adolescent Sierra talks at length on the phone with her friends. On the other hand, they don't own a television. They pass the evening hours reading, telling stories, looking at photos, and sharing quality time together. "Normal" families seem to do this once a year at Christmas or Thanksgiving, and they savor it as something rare and special, but this is what the Rosses do every night. They're comfortable with themselves and each other, and they embrace a balanced lifestyle that much of our society seems to have lost track of.

When our visit came to an end, Jason and I drove toward the interstate and talked about the beauty and simplicity of the Rosses' lives and how cool it was that they didn't create or have to deal with so much stress. We both felt that staying with the Rosses for a couple of days was fantastic, because we were forced to take a break. We had downshifted and focused on what really counts in life. Then, just as we reached the interstate, both our cell phones started beeping for the first time in three days, and all that simplicity disappeared. Jason had fourteen messages, but I beat him with seventeen. In that moment, I could feel my life accelerating back to its normal pace again, just as we were racing up the on-ramp into freeway traffic.

14

ED VIESTURS

After climbing 14,410 feet for the 191st time, Ed Viesturs poses for photographs. He stands atop a small snow pyramid, the high point on a mile-wide crater rim, while his clients gather around and smile. Few people could pick out Ed on the street, but on Mount Rainier he's instantly recognizable as a mountaineering legend who has reached the summit of Mount Everest six times. To get to the top of the world, though, Ed first punched the clock on this menacing volcano in the northwest corner of the continental United States. "Rainier is the full meal," he says. It offers the challenges, including glaciers and severe weather, of a Himalayan peak—in a "smaller, condensed form."

Mount Rainier isn't the tallest in the country, but Ed believes there isn't another mountain in the United States, outside of Alaska, that offers so much to somebody wanting to learn about big-mountain climbing. "There's not many places in the lower forty-eight where you get glaciers and the conditions similar to what you get in the Himalayas." At least twenty-five glaciers, some of them several miles long, drape Rainier's flanks. These flowing rivers of ice are the conduits to the summit. Climbers ascend nearly ten thousand vertical feet, mostly on ice and snow. Because Rainier is a volcano, it lacks high-quality rock for climbing, and most nights there's a constant chorus of rockfall from crumbling ridges and cliffs poking through the ice.

Those who attempt the mountain also contend with a potentially treacherous microclimate. "You get some bad weather, you can get hammered," Ed warns. Located in the Cascade Mountains of Washington State, Mount Rainier receives massive snowfall, often more than eight feet a year. It can snow

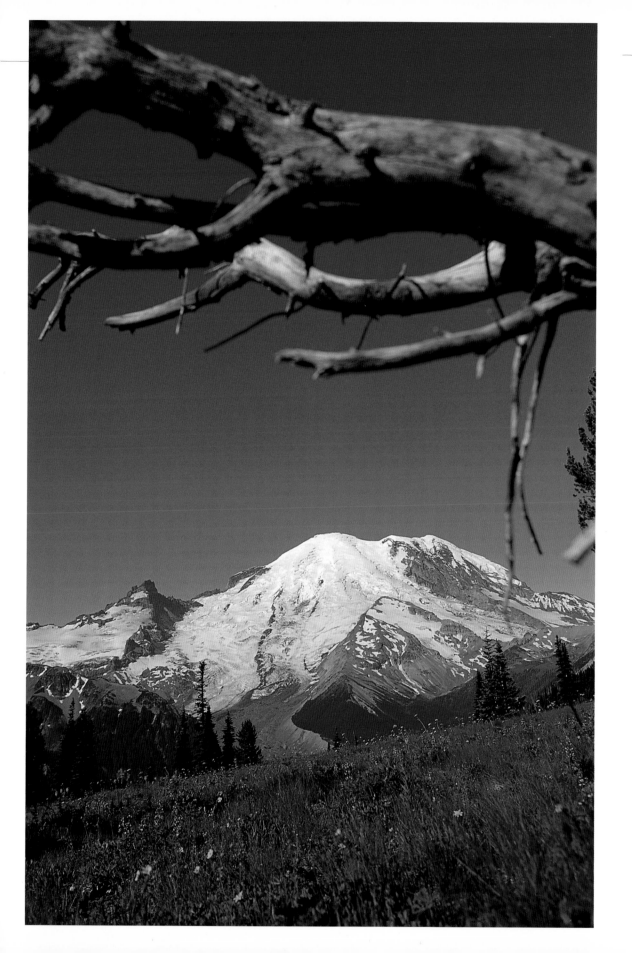

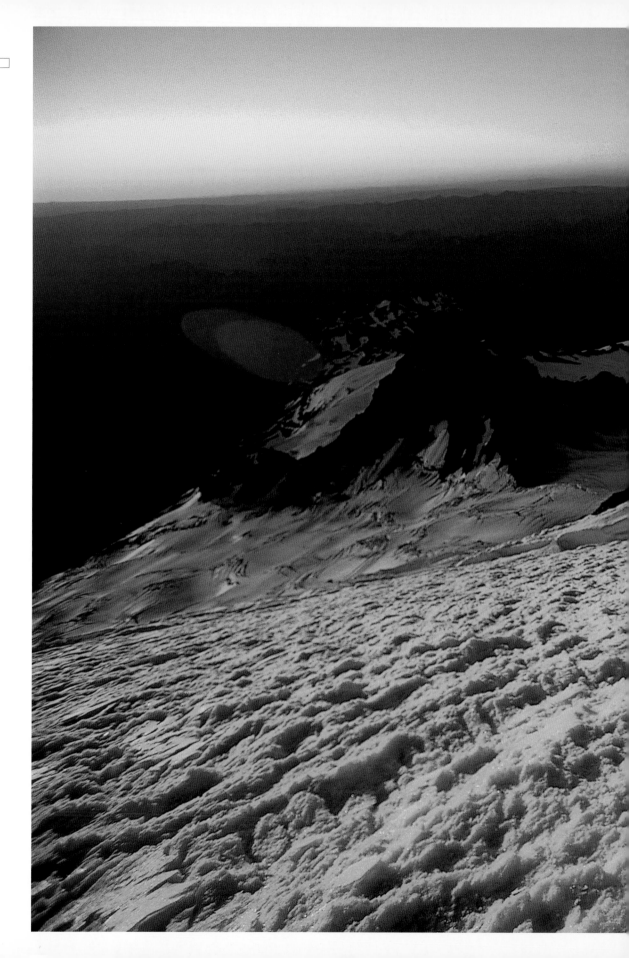

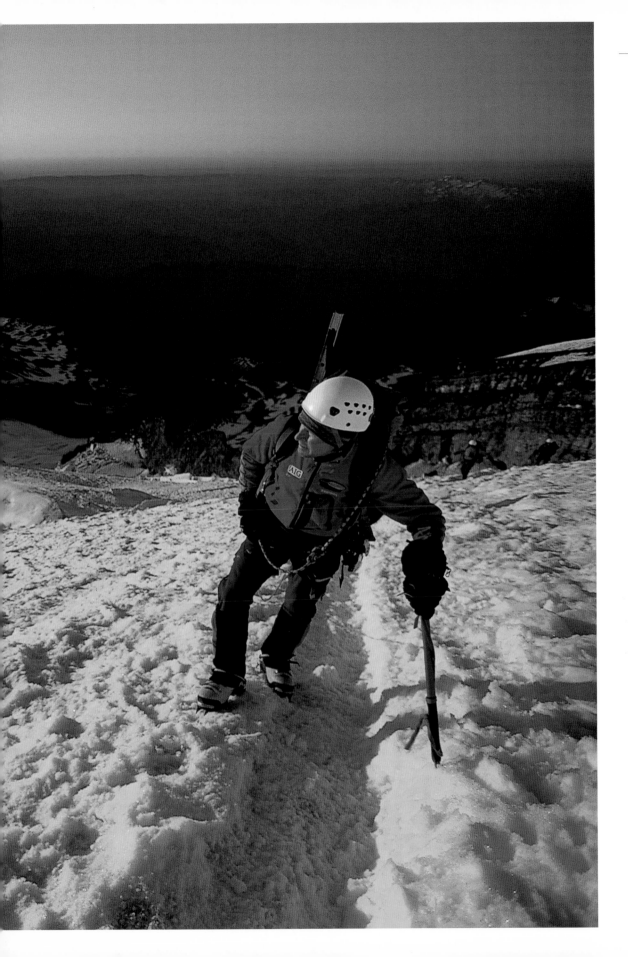

in August, and temperature inversions can deliver a frigid rain in January. "If you learn to deal with those things here, you can deal with them just about anywhere," says the Himalayan veteran. But the massive size of the mountain that creates this microclimate also provides solitude. Move one glacier over from the most popular routes and you'll find yourself alone amidst towering icefalls and deep blue crevasses. Standing alone high atop Rainier, climbers see only open sky and their own small slice of the volcano, creating a sense of remoteness not often felt in other mountain ranges.

Ed grew up on the endless plains of Illinois. One reading of Maurice Herzog's *Annapurna* drove him west in 1977 in search of high peaks. "All the great [American] Himalayan climbers came from this area," he remembers, "so I figured it would be a good place to start climbing." He didn't plan on making mountain climbing his life—the volcano changed his mind.

Ed could see Rainier from his dorm room window at University of Washington in Seattle. Along with attending college classes, he began training on easier peaks, including Mount Saint Helens. "My first objective was to learn enough and train enough and climb Rainier," he says. Ed eventually scaled Rainier for the first time in the middle of winter, when there are no crowds and a blanket of snow covers all, creating a landscape of uniform stillness. But short days and a greater chance of bad weather mean the serenity rarely lasts very long. "We made two or three attempts," Ed recalls, "[and] we got spanked a few times."

As his mountaineering skills improved on Rainier and elsewhere, Ed found that he could make a living as a climbing guide, a career he knew

required more show than tell. "I learned to keep my mouth shut, listen, and let my actions speak for [me]," he says. Ed quickly stepped up to Alaska's Mount McKinley, Everest, and other peaks. "In the early days," he says, "Rainier was my ticket to the big mountains."

Guiding on Mount Rainier taught Ed many of the skills that he continues to use when climbing the world's tallest peaks today. "On Rainier," he says, "you always have to evaluate what's around you. Things could go well, but they could also go bad, and quickly." He adds, "You have to learn to be patient and you have to be strong, because you have the biggest pack of anybody." Ed says the physical and mental demands that he acquired during his decade plus on Mount Rainier have proven invaluable on many of his biggest ascents. "On Everest you have to be able to get up every day and really push yourself for eight weeks."

These days he circles the planet in search of higher summits, but Ed always returns home to the Seattle area and to Rainier. With the summit pictures snapped, he and the others head down the mountain's ice-covered flanks, hopping over a crevasse, carefully negotiating the volcanic rock in crampons. He's grinning when others might grimace at the descent. Another successful climb behind him, Ed reminds the others of his mantra: "Getting up is optional, getting down is mandatory."

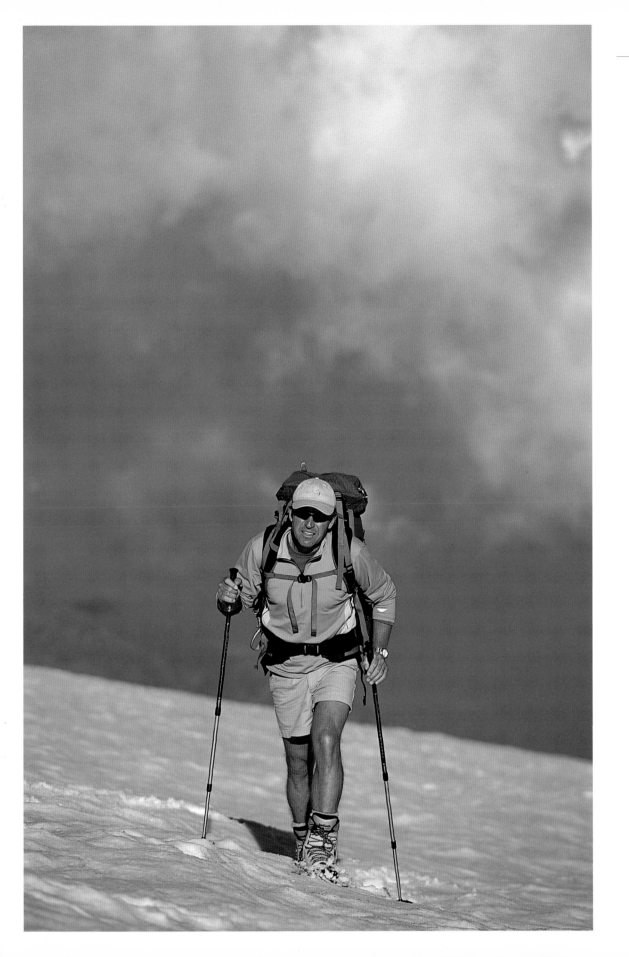

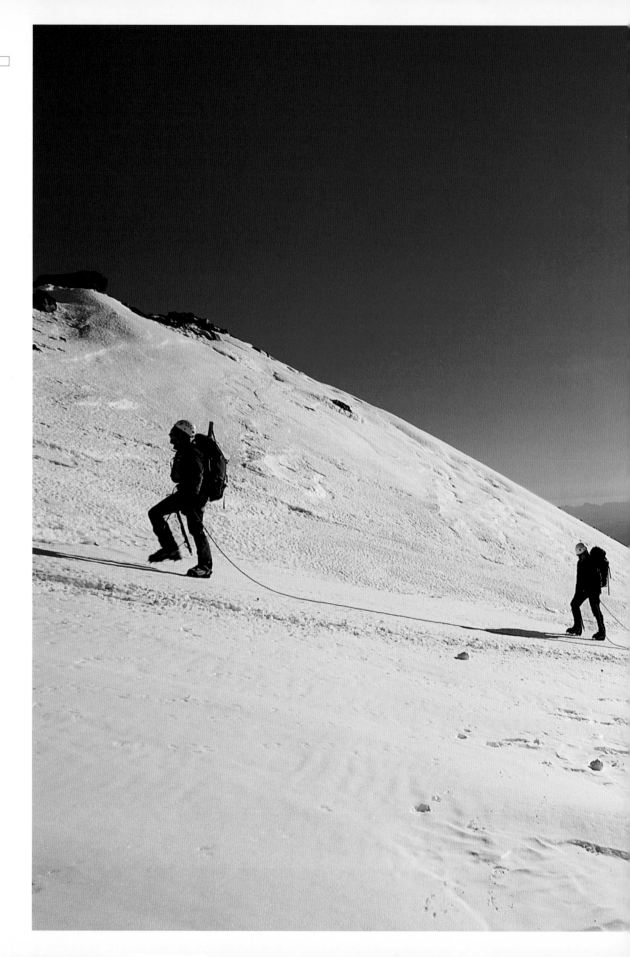

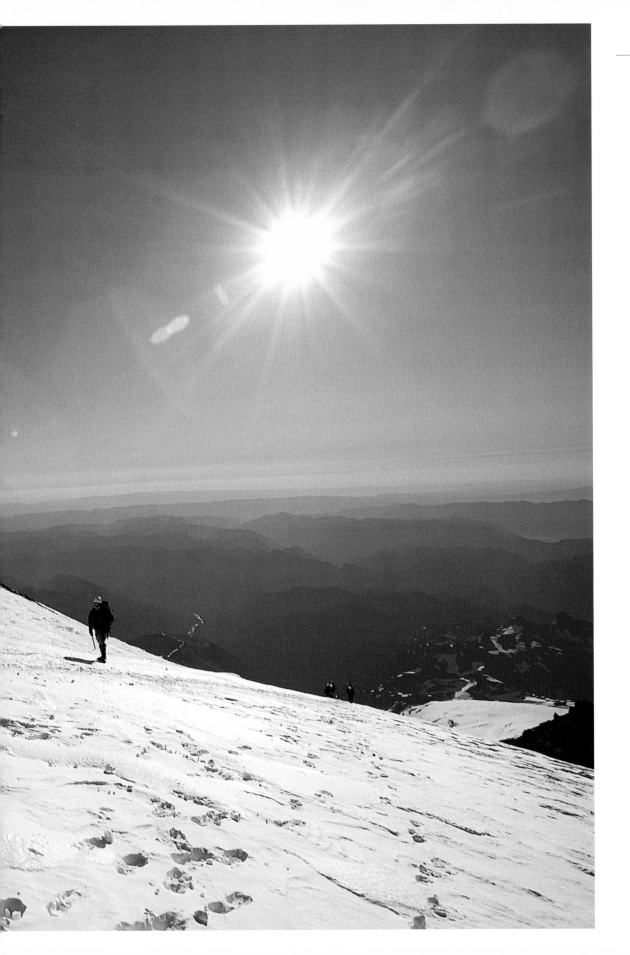

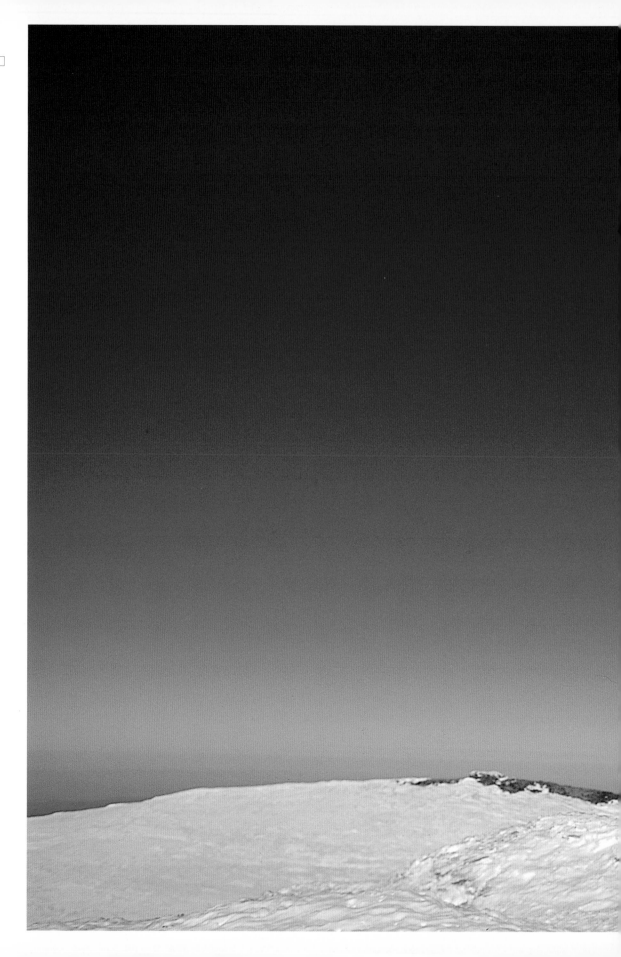

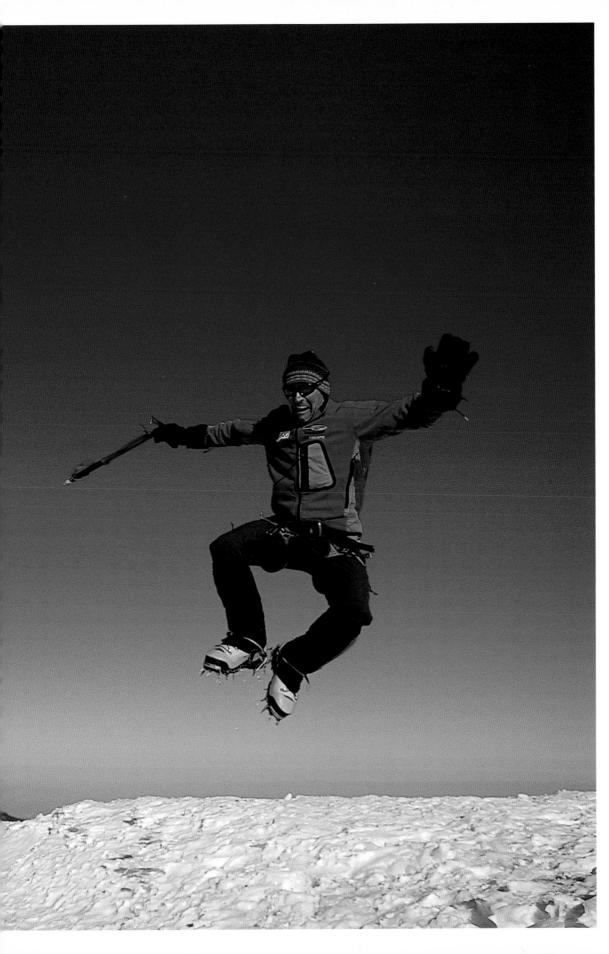

PAGE

PHOTOGRAPHER'S
NOTES:

I HAD THE LUXURY OF SPENDING several days with many of the athletes in this book; with Ed I had less than twelve hours, eight of which were spent hiking in the dark. This is just the nature of climbing a mountain like Rainier. Much of the ascent is done in the early hours of the morning, when the snow is still frozen solid and the mountain is safest and easiest to climb. With basically four hours to take photographs, every minute counted and every image I captured was key.

On top of the time constraint, I had to be physically prepared for Ed's high-altitude environment—the snow and ice conditions, the weather, and the safety concerns. *And* I had to be a creative photojournalist, critical of the light, the moment, and the composition. These kinds of situations are what make me so passionate about what I do. I am an active participant in the things that I photograph, not just an observer. Fortunately, there was an unsung hero on this difficult shoot: my partner on this book, Jason Paur.

Jason was my climbing partner; he was tied to me by a rope and was essentially at the mercy of my direction the entire time. As a photographer, I need to get myself into the perfect position to shoot photos. This is not always easy, especially in a high alpine environment with unstable conditions. Jason was frequently forced into very uncomfortable, awkward, and sometimes downright unsafe positions on my behalf, and many of these photos would not have been possible without Jason's selfless help.

"Light and fast" was the key to climbing Mount Rainier with Ed Viesturs. The less camera gear and climbing equipment we had with us, the faster we could move, so I went with one camera body, one extra battery, two lenses, and only twenty rolls of film. I didn't bring a flash, a light meter, a lens hood, or a tripod. My climbing gear consisted of only an ultralight mountain ax, a thin light harness, superlight crampons, and my mountaineering boots.

Experience has taught me that I can get by with fewer tools—sometimes it's not about the equipment you have, but how you use it. We packed well and planned perfectly. When the sun started to come up, I forgot that we were nearly fourteen thousand feet above sea level. My mind was clear and I could just focus on shooting; I was in the sweet spot. Trusting my skills, my past experiences, and my partner definitely paid off.

ACKNOWLEDGMENTS

We would like to thank the many people who helped
with this project: the staff at Chronicle Books, espe-
cially Sarah Malarkey, Matt Robinson, and Jay Peter
Salvas, for their tireless support and endless help
in making this book possible; the adventurers fea-
tured in each chapter, and their families, for allow-
ing us into their busy schedules and giving us a glimpse
into their lives.

Thanks also to the friends, family, and people
we met at the many spots during the long hours of
documenting favorite places around the country: Mark
Anders, Justin Bailie, Justin Bastien, Damian and
Willie Benegas, Porter Binks, Rich Clarkson, Miles
Dasher, Hans Florine, Robin de la Fuente, Jimmy
Halliday, J.T. Holmes, Sara Longenecker, Kristen
McClarty, Ouray Victorian Inn, Rob Raker, David
Rich, Jane Sievert, Adam Stack, Kari Stein, Brooke
and John Stewart, Kevin Swift, Wendy Sykes, Max
Weintraub, and Peter Whitaker/Rainier Mountain-
eering Inc. Corey would especially like to thank
Kim Miller for her love and enthusiasm.